Drawing On Brilliance

Randy Rabin & Jackie Bassett

authorHOUSE®

AuthorHouse™
1663 Liberty Drive
Bloomington, IN 47403
www.authorhouse.com
Phone: 1-800-839-8640

First published by AuthorHouse 8/3/2009

ISBN: 978-1-4389-9223-5 (sc)

Printed in the United States of America
Bloomington, Indiana

This book is printed on acid-free paper.

INTRODUCTION

Imagine trying to develop a bicycle or automobile for roads that were not yet paved. What must it have been like to create the first electric light without electric light to work by? How challenging was it to develop anything in a lab during the summer without air conditioning or even electric fans? Yet, inventors persevered and brought us ground-breaking ideas and created entire industries.

Almost every technology that is part of our lives today can be found in its infancy in the 1800's. For example, the Internet flows from the telegraph and telephone, the laser from the light bulb, the digital camera from film photography.

Scores of books have been written about inventions – from the great to the silly. This book had a different origin: as the US Patent Office looked at its 200 year old collection of over 6 million patents, management decided a digital collection was more efficient than a paper library - then threw all of the original documents in the trash. As the shredding squads moved room by room through more than a dozen buildings, the lithographs in this book, somewhat frail but still intact, were rescued.

Some of the inventions may be more familiar than others. But all have lessons for the problem solvers of any era. Find a drawing that intrigues you, then go to our website to see the rest of the patent: www.drawingonbrilliance.net and www.drawingonbrilliance.com.

Note how each inventor actually stood on the shoulders of others, for example by borrowing parts, or benefiting by analogy. See how you might incorporate their thinking into your own problem solving.

A LIBRARY OF INVENTIONS

Thomas Jefferson had a profound idea when he shaped the US patent system in the 1790's. As both an inventor and a scientist interested in many disciplines, he had little interest in the property aspect of a patent; he saw the patent system as a unique opportunity to gather technical knowledge from many sources into one collection.

In exchange for giving an inventor patent protection for a set period of time, Jefferson required the inventor to disclose every aspect of his invention or discovery to a degree that would allow another skilled person to understand and produce the invention, and to submit the invention to a rigorous examination by trained experts.

Even Jefferson was surprised by the result: inventions poured forth in every field, from power generation to chemistry, and metallurgy to agriculture. By 1835 there were 10,000 patents. By 1911 there were one million.

The lithographs illustrated in this book are of the actual documents that many generations of patent examiners handled every day, complete with hand written notes and decades of fingerprints. They were all an integral part of the patent process.

Comments in this book are brief by design. To learn more, please visit our website, www.drawingonbrilliance.com. There, you will be able to view each patent in entirety, and to add your own comments to a blog.

Collector inquiries: The original documents are available to collectors by contacting us through the website.

Horse Power - before Engines

In the early 1800's, a farmer or craftsman had few choices to power a grain mill or saw. A water wheel was one answer, if moving water was nearby. Everywhere else, animal power was the only major source. A horse was dependable and required few skills to operate. Converting an animal's linear motion to rotary power produced the equivalent of the water wheel. A rotating shaft then could transmit the power some distance.

Note the patent number preceded by an "X". The great Patent Office fire of 1836 consumed everything in the building, including all patent documents and models dating back to the first patent in 1790. An appeal went out to inventors to return their original patents so copies could be produced. The pre-1836 collection was then designated the "X" series to distinguish it from those that were issued (starting with No. 1) after 1836.

Since horsepower was the metric people already valued, it was used as the metric to measure power in future inventions such as automobile engines. Key to innovation success is measuring metrics that matter.

Look at what people are already trying to get done. Build a product that doesn't require them to significantly change their behavior.

Isaacs & Willbanks,

Horse Power.

2,862 X

Patented Oct. 14, 1817.

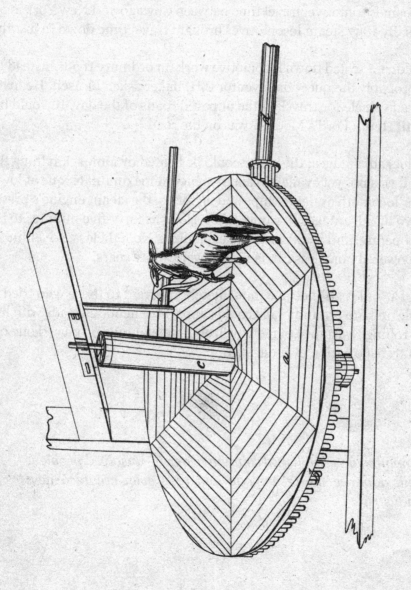

ENERGY FROM STEAM POWER

Before the steam locomotive, travel time between Chicago and New York averaged three weeks. By 1857 steam locomotives brought travel time down to just three days.

So why couldn't a scaled down locomotive work on ordinary roads instead of on rails? That was probably the question inventor C.H. Baker asked himself. He invented this steam-powered vehicle for travel on the unpaved roads of the day. It would be another three decades until Henry Ford's Model T was on the road.

Steam power had its advantages: the boiler could be heated by almost anything that burns (coal or wood – oil was not yet available) and it achieved maximum torque at low speed. Although ideal for locomotives, large ships and factories, the steam engine's pressurized boiler had two disadvantages: it would take as long as forty-five minutes to build up enough steam to operate, and it was prone to exploding. Nonetheless, adventurous drivers opted for steam powered horseless carriages for over twenty years.

The advantages of a "rail road" became immediately apparent to those who tried to operate a heavy vehicle on bare ground: rails could support tremendous loads with little wear, and the very low rolling resistance of metal wheels on metal rails produced one of the most efficient forms of transportation ever devised.

Applying an established solution to a new, unsolved problem will advance the technology and may even create a new industry

No. 28,955.

PATENTED JULY 3, 1860.

C. H. BAKER.
STEAM CARRIAGE FOR COMMON ROADS.

3 SHEETS—SHEET 1.

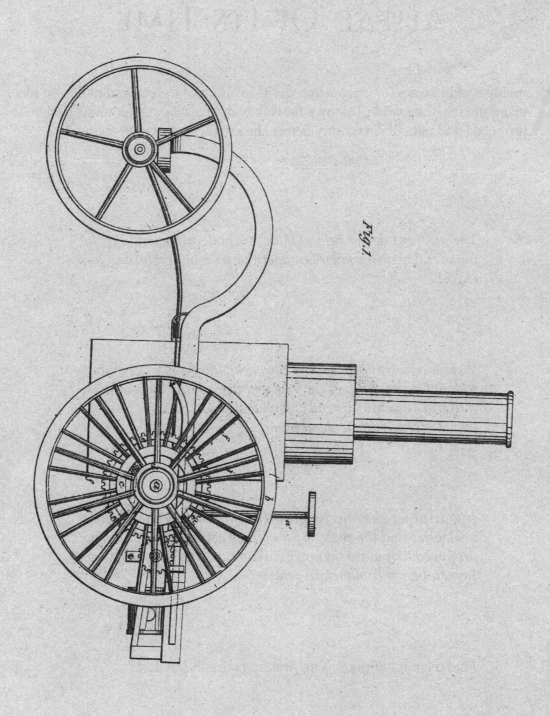

Fig.1

ENERGY: A CENTURY AHEAD OF ITS TIME

Already seeking ways to improve speed, the inventor of the streamlined train recognized the friction losses of air on a moving body. This forward-looking design was proposed and patented a century before the arrival of the bullet trains.

The business driver behind bullet train development was to make rail transport more competitive with both road and air travel.

Visionaries are by definition "too early". So if you truly intend to build a new technology that will disrupt the market with that truly essential product, you have to understand what his world is like today without it.

If your target customer is satisfied with his current alternatives or doesn't find the reasons for change compelling to him, be prepared to finance the gap between now and when he does. Remember: it could take a century.

Find a compelling problem first and the solution last!

S. R. CALTHROP.
CONSTRUCTION OF RAILWAY TRAINS.

No. 49,227.

Patented Aug. 8, 1865.

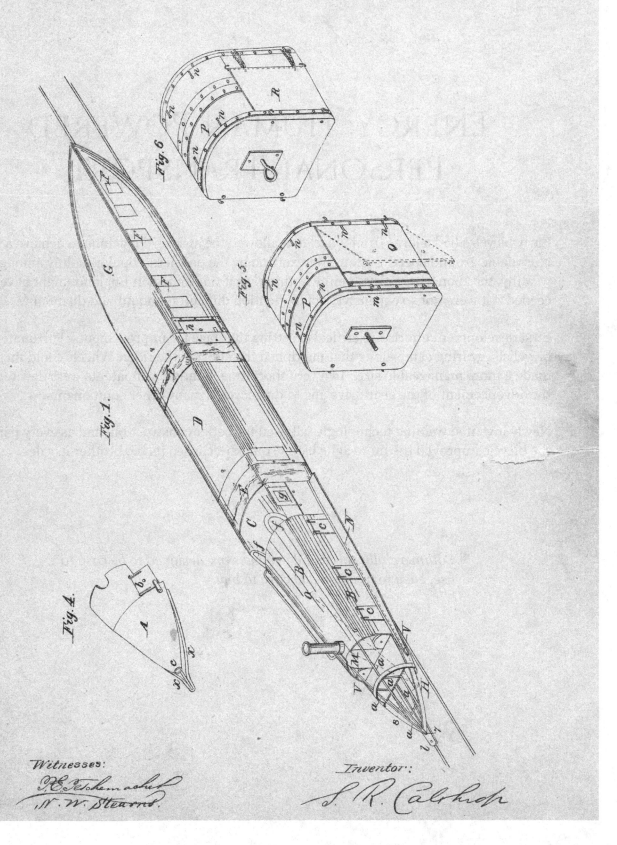

Fig. 6.

Fig. 5.

Fig. 1.

Fig. 4.

Witnesses:

Inventor:

S. R. Calthrop

Energy: Human Powered Personal Transport

Early bicycles had a large front wheel that allowed the awkward machine to achieve a reasonable ground speed without overexertion by the pedaler. Popular mainly among the wealthy, the "boneshaker" or "penny farthing" as it was known in England might have succeeded if it were not so expensive, not to mention difficult to mount and dismount.

First development efforts are critical to setting the stage for improvements. Fortunately for bicyclists, gearing came along that multiplied the effort of the rider. Wheels could then be made a more manageable size. In a very short time, hundreds of patents were devoted to the advancement of the gear drive and to the bicycle's many other components.

Newly invented welding technologies allowed for better construction, and as every part of the bicycle improved the more agile bicycle quickly eclipsed its big brother in sales.

Commercially successful products are designed to be easy to use, easy to manage and easy to buy.

(No Model.)

C. E. DURYEA.
BICYCLE.

No. 364,231. Patented June 7, 1887.

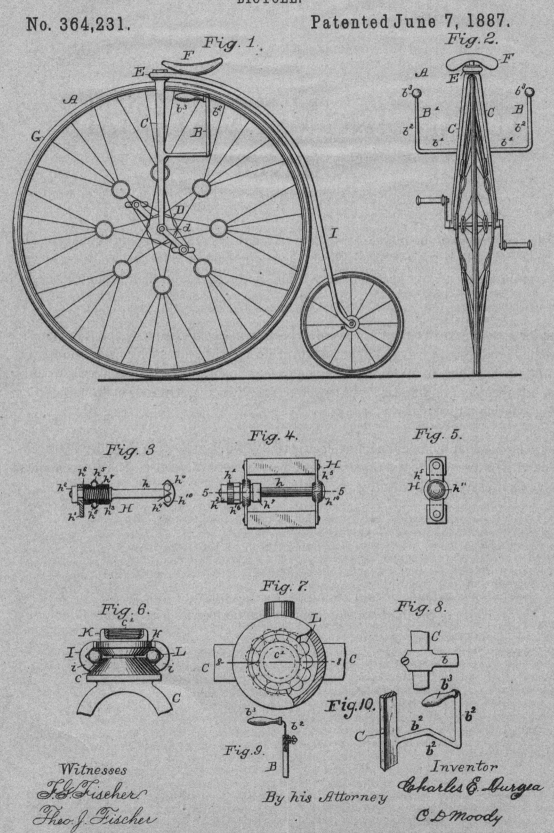

Fig. 1.

Fig. 2.

Fig. 3.

Fig. 4.

Fig. 5.

Fig. 6.

Fig. 7.

Fig. 8.

Fig. 9.

Fig. 10.

Witnesses

J. G. Fischer

Theo. J. Fischer

By his Attorney

Inventor

Charles E. Duryea

C. D. Moody

ADVANCING VIA MATERIALS SCIENCE

The core design of the bicycle as we know it today has remained almost unchanged from its earliest days: a more efficient geometry has yet to be devised. Even bicycle components - pedals, gear changers, chains and seats found their best forms early on.

One major area of improvement however has been in *materials*. Advancement in materials science has produced a variety of lightweight yet strong materials such as aluminum, titanium and carbon fiber. In addition, the methods used to fabricate these materials would evolve. Advancement in materials was driven primarily by the demands of the rapidly evolving aviation industry.

This bicycle was adapted to connect to electric trolley wires - allowing the rider to travel free where the wires went - and under his own power everywhere else. There was no need to charge or to carry heavy batteries.

Look outside of your industry for the missing link in the chain of product development: it will accelerate innovation success.

(No Model.)

R. T. ONEY.
TROLLEY BICYCLE.

No. 588,465. Patented Aug. 17, 1897.

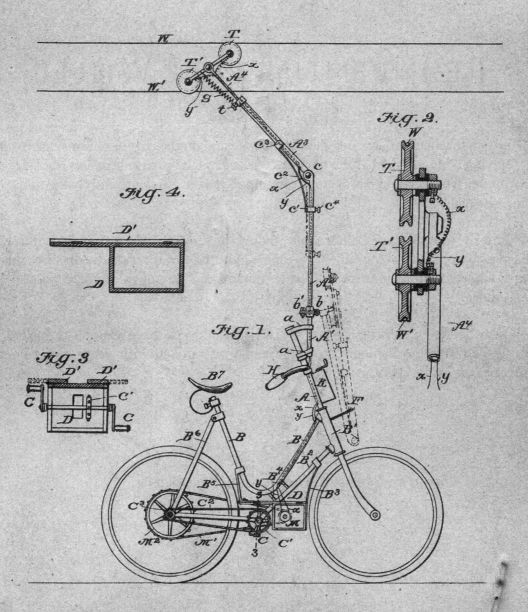

Fig. 2.

Fig. 4.

Fig. 1.

Fig. 3.

WITNESSES:
Jos. A. Ryan
Edw. U. Byrn.

INVENTOR
Robert T. Oney.

BY Munn & Co.

ATTORNEYS.

Re-inventing the Wheel

The single wheel velocipedes shown opposite and on the cover are remarkable for solving a big problem at the time: travel over rough, unpaved roads. The large diameter wheels could travel almost unimpeded over rough ground that would trip up smaller wheels.

A low center of gravity made balance easy, though turning could be a challenge and the rider's view was partially blocked. More than a hundred variations on the basic theme included wheels adapted to travel over water and on rails. Engine powered versions would appear later.

The single wheeled velocipede has been adapted into the space age as a self-propelled sphere, sealed from the elements, solar powered and complete with electronics, cameras and sensors for exploring other planets.

Always explore new uses for existing technologies.

J. RAWLE.
UNICYCLE.

No. 482,100.

Patented Sept. 6, 1892.

301

X130

Fig. 1.

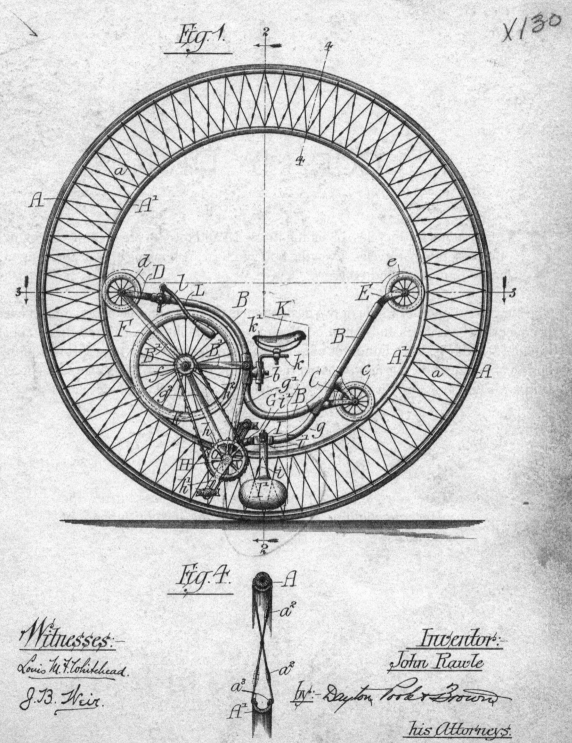

Fig. 4.

Witnesses:-
Louis M. F. Whitehead.
J. B. Weir.

Inventor:-
John Rawle
By: Dayton Pook & Brown
his Attorneys.

SUCCESS BY DESIGN

Components for bicycles, including the pedal and toe clip are instantly recognizable on present day bicycles. Even the bolt and bearing housing appear unchanged after more than one hundred years.

The bicycle is a great example of two design tenets that have characterized almost every product that has successfully endured: the interchangeability of parts and the establishment of standards. With hundreds of millions of bicycles in use, a new part must interchangeably fit one bicycle as well as another. The manufacturer relies on a set of accepted standards (e.g. bolt and thread size) so that his new pedal will fit all bicycles.

Two key tenets of new product success are: the interchangeability of parts and the establishment of standards.

H. W. LESTER.
TOE CLIP FOR VELOCIPEDE PEDALS.

No. 535,065. Patented Mar. 5, 1895.

Fig. 1.

Fig. 3.

Fig. 2.

Fig. 4.

Witnesses:
J. L. Edwards Jr.
Fred. J. Dole.

Inventor:
Howard W. Lester.
By his Attorney.
F. H. Richards.

Far Ranging Effects

In the early days of patent filings, society did not encourage women to own property, including patents. Some filed in their husband's name or adopted a gender neutral name. Some of the women were extraordinary and a few who were discovered in this rescued collection of patents are included in this book.

The bicycle brought about many social benefits. The draw of personal mobility attracted many women cyclists as the bicycle improved with gear-drive, pneumatic tires, and an adaptable frame.

Women found alternatives to their constrictive clothing as in the case of this 1896 bicycle garment. With the help of many buttons and buckles this garment "permits the rider to appear in ordinary dress while walking and in the desirable and convenient bloomer–suit when riding."

Look at what market changes are already occurring and how they could affect demand for your product.

M. BECK.
BICYCLE GARMENT.

No. 565,066. Patented Aug. 4, 1896.

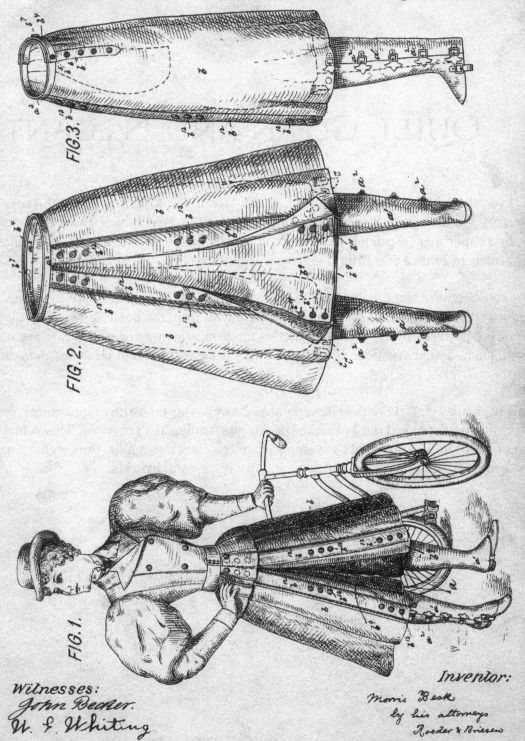

FIG.3.

FIG.2.

FIG.1.

Witnesses:
John Becker.
W. S. Whiting.

Inventor:
Morris Beck
by his attorneys
Roeder & Briesen

Quiet, Clean and Elegant

If you thought the gasoline engine powered Model T was the first successful car on the road, think again – the first commonly available powered vehicles were *electric*. The first experimental models date from the 1830's. By the 1890's they were common on the streets of France and Britain and soon after in the US.

The vehicles were remarkably easy to operate, quiet and smokeless. Built by scores of independent carriage makers who evolved their vehicles from the horse drawn variety, electric cars were powered by motors and batteries made mostly by Edison. The carriage makers distinguished their creations from their competitors' with elegant interiors and adornments.

This particular electric vehicle incorporated many advanced features including a centrifugal clutch that engaged only when the motor was turning at a set speed. This vehicle's motor also could perform as a generator when traveling down hills, thus recharging the battery, a feature found on some present day electrics and hybrids.

Outsource all non-differentiating tasks so you can capitalize on your core strengths.

W. A. CROWDUS.
AUTOMOBILE VEHICLE.

No. 598,314.

Patented Feb. 1, 1898.

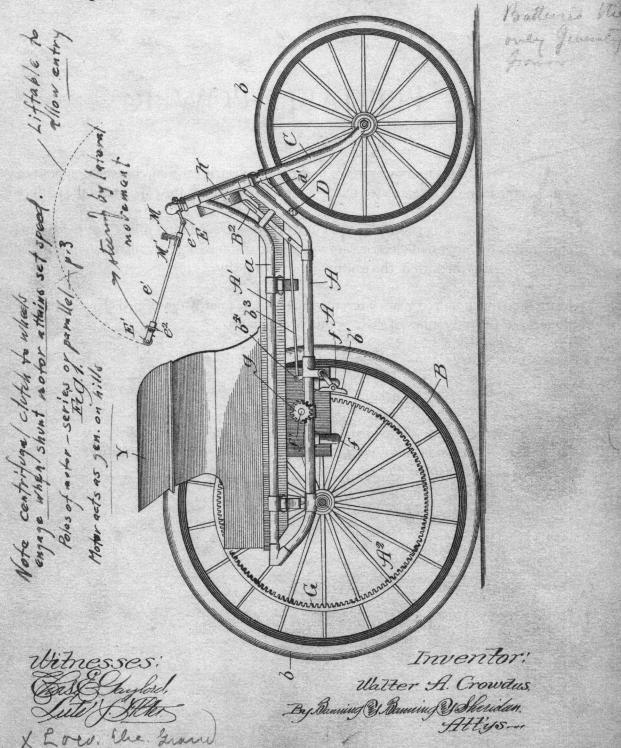

Fig. 1.

Note centrifugal clutch to wheels engage when shunt motor attains set speed.

Poles of motor – series or parallel – p. 3

Motor acts as gen. on hills

Liftable to allow entry

intent by several movement

Inventor:

Walter A. Crowdus

By Banning & Banning & Sheridan,

Att'ys.

PORTABLE POWER

A long-lasting battery was at the heart of the electric car's success. Edison poured considerable research for many years into increasing the capacity of the battery.

The travel range of these early electric cars averaged forty miles. But recharging constraints required that electric cars stay within distance of an available source of electric power, which at the turn of the century was still a rarity.

More than one hundred years later, the range of most newly developed electric cars does not exceed the forty miles of their primitive ancestors.

Find a category that needs improvement, make it exponentially better and you can advance multiple industries at once.

T. A. EDISON.
ALKALINE BATTERY.
APPLICATION FILED JULY 21, 1904.

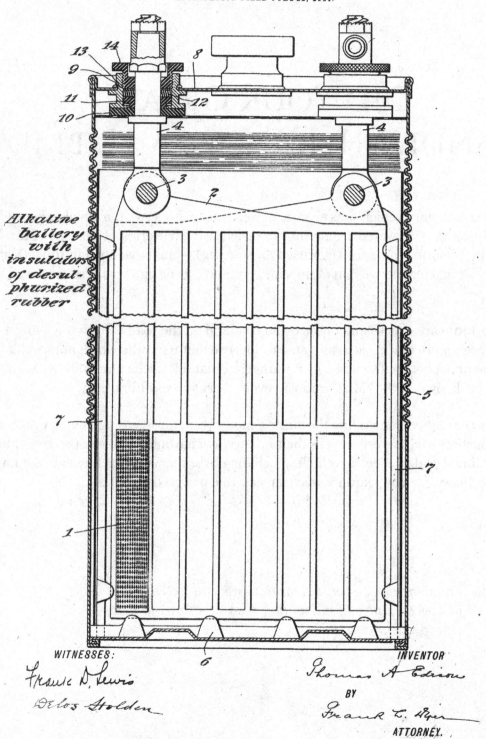

Alkaline battery with insulators of desulphurized rubber

WITNESSES:
Frank D. Lewis
Delos Holden

INVENTOR
Thomas A Edison
BY
Frank L. Dyer
ATTORNEY.

DID YOUR GREAT GRANDFATHER DRIVE A HYBRID?

This revolutionary vehicle was electric powered but with a twist: a small onboard gasoline engine powered a generator to recharge the batteries. It was one of the very first hybrids (note the tiller used for steering) – and developed in 1901. Despite the existence of this patent, we don't know for certain if this design was ever produced in America.

However, in 1901 cars, trucks and buses could be found on the roads of Austria using a similar but even more advanced arrangement. Electric motors in the wheel hubs made a transmission unnecessary. Designed by a young Ferdinand Porsche and built by Daimler, the hybrid was known as the "Mixt" and was even a very successful racecar.

The hybrid's components including the electric motor, generator, storage battery and internal combustion engine were each in their infancy. Each would be developed separately over the coming decades. Electric vehicles, including hybrids, were sidelined almost immediately by the sudden appearance of cheap gasoline powered vehicles.

Collaboration – in a world more connected than ever, fosters a culture of innovation success – sharing ideas "one entrepreneur at a time".

No. 668,262.

D. N. MELVIN.
MOTOR VEHICLE.
(Application filed June 14, 1900.)

Patented Feb. 19, 1901.

-(No Model.)

4 Sheets—Sheet 1.

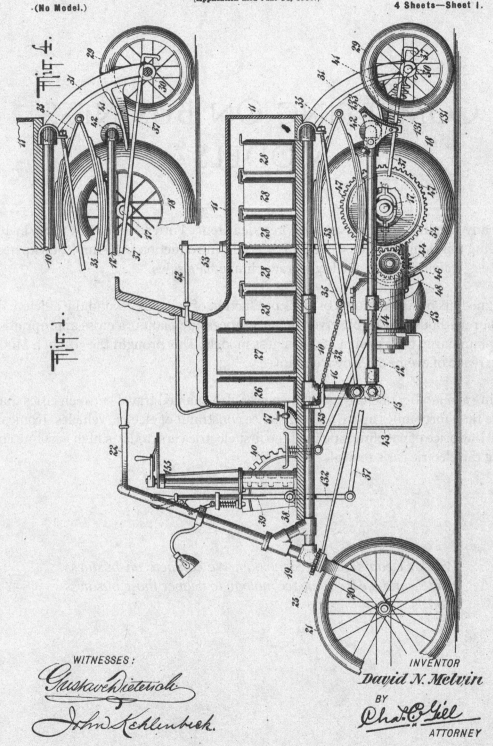

WITNESSES :

Gustave Dieterich

John Kohlenbeck.

INVENTOR
David N. Melvin

BY

Chas C. Gill

ATTORNEY

Competing On Business Models

Many gasoline powered vehicles preceded Henry Ford's Model T of 1908, including the Daimler three wheeler. But Ford's introduction of a simple, inexpensive, easily maintained vehicle generated immediate sales.

Ford designed his business model of mass production of vehicles around the efficient division of labor methods that he observed in meat processing plants, a cross appropriation of ideas now familiar in both design and business models. This brought the cost of a Model T within the reach of even Ford's own employees.

The growing availability of cheap gasoline power also enabled travel between cities that were more than forty miles apart, a key distance constraint of electric vehicles. Ironically, just as the low price of gasoline sidelined the first electric cars, today's high gasoline costs are fueling the electric car's revival.

We don't compete on technology. We compete on business models and we leverage technology to deliver those business models.

24

G. DAIMLER.
ENGINE DRIVEN VEHICLE.

No. 376,638.

Patented Jan. 17, 1888.

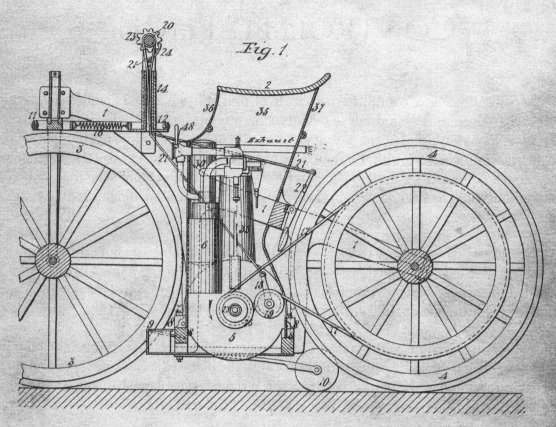

Fig. 1.

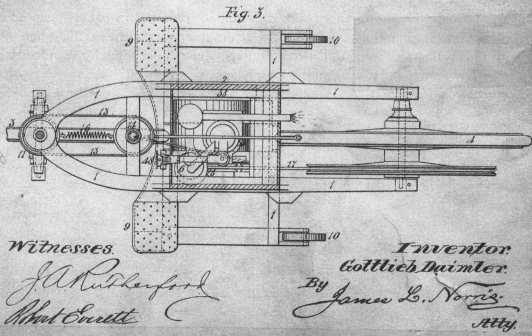

Fig. 3.

Witnesses.

J. A. Rutherford

Robert Everett

Inventor.
Gottlieb Daimler.

By James L. Norris

Atty.

CONTROLLED FLIGHT

Few inventions have continued to excite the world as has manned flight. Prior to the Wright flyer, many hundreds of patents show attempts to fly, often with combinations of balloons with propellers, steam engines with helicopter rotors, or complex arrays of wings and propellers for lift. Extreme weight to lift ratio was just one of their problems. The variety was endless – until the Wright brothers came along. Their seemingly simple wing produced lift as the craft was propelled forward. Competitors quickly followed their lead.

The Wrights relied on secrecy to keep competitors at bay. Their basic but critical improvements included a wing shape that provided lift, with an engine and a propeller design that provided the needed thrust. A complex but practical method to control the direction and behavior of the craft brought true success to "controlled flight."

This patent discloses the control means, using ropes and pulleys that enabled the pilot in flight to bend and curve the wing surfaces to cause the plane to ascend, descend and turn. Prior to publication of the patent, details of the Wrights' control mechanism were not apparent to competitors, nor was the wing shape that produced lift.

So why were two bicycle shop owners from Ohio able to accomplish what centuries of masters from da Vinci to Lilienthal could not? The achievement of controlled flight had little to do with the problems of weight, thrust or drag that every other flight hopeful focused on. The problem was pitch and yaw, something bicyclists are experts at.

Fix the right problem, first!

O. & W. WRIGHT.
FLYING MACHINE.
APPLICATION FILED FEB. 10, 1908.

1,075,533.

Patented Oct. 14, 1913.

5 SHEETS—SHEET 1.

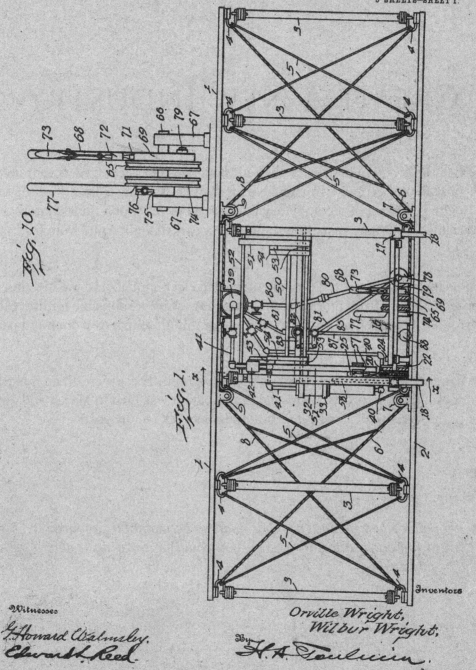

Fig. 10.

Fig. 1.

Inventors

Witnesses

G. Howard Walmsley

Edward L. Reed

Orville Wright,
Wilbur Wright,

By H. A. Toulmin

Attorney

CREATE A NEW INDUSTRY

When the problem of heavier-than-air flight was not yet solved, inventors proposed every geometry imaginable for their crafts. The role of the wing in providing "lift" was not completely understood by most potential aviators – even after the Wrights flew. Many casualties in the early years of flight came from testing faulty designs.

Propulsion using engine-powered propellers seemed clear enough and the inventor of this craft proposed one both front and rear. Sail-like wings were responsible for lift. Clearly expecting trouble, the inventor provided the pilot of this air ship a trap door and parachute.

Notice the hand written examiner notes on this lithograph. These were all an integral part of the patent examination process. This particular patent was filed in March and awarded in October of the same year. Patent approval today can take many years.

*Failure just means "not that way" so be mentally prepared
to fail early and fail often – you could be creating a new
industry!*

No. 869,238.

PATENTED OCT. 29, 1907.

A. W. H. GRIEPE
AIR SHIP.
APPLICATION FILED MAR. 8, 1907.

4 SHEETS—SHEET 1.

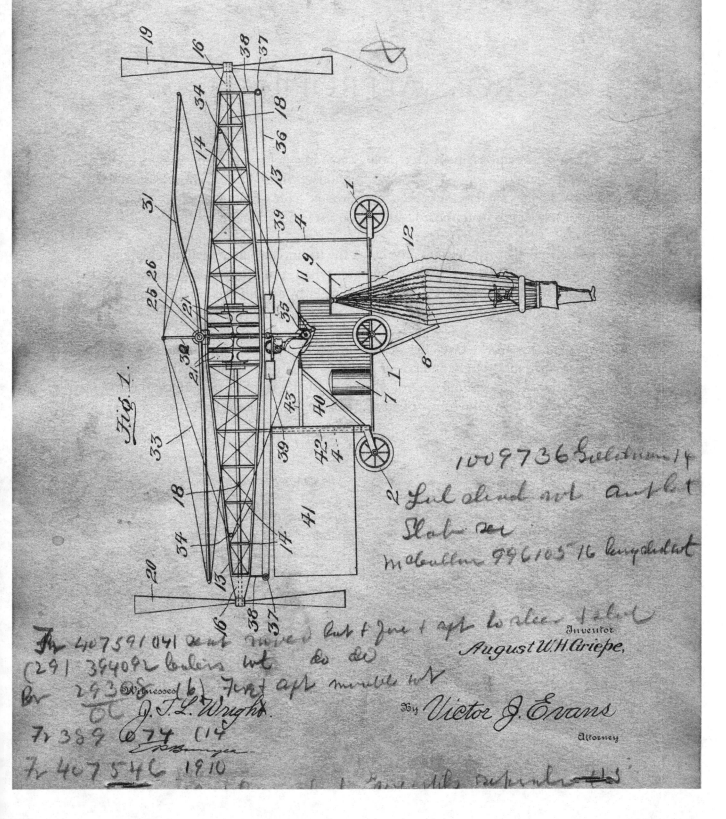

Fig. 1.

Inventor
August W. H. Griepe,

By Victor J. Evans

Attorney

Witnesses
J. L. Wright.

CROSS APPROPRIATE

Many inventors cross lines of technology and advance entire industries by adding their own unique ideas. George Westinghouse, whose first inventions included safety devices such as air brakes for railroads, later turned his genius toward the development of telephone switchboards and AC power generation.

Alexander Graham Bell spent decades advancing the technology and reach of telephony before turning his sights to flight. In this 1913 patent, Bell recognized a key weakness in the Wrights' design for future aircraft: the pilot had to steer by artfully flexing the wings, much as a bird corrects course.

The imitation of nature worked well for the Wrights' very light aircraft. But Bell recognized that advances in aircraft strength and power required structural rigidity. Bell added a movable vertical rudder for directional control, allowing left and right turns with rigid wing structures. In a single move the future of aircraft design was advanced.

Cross appropriate those practices, processes and technologies that work successfully in one industry – into a completely different industry.

1,050,601.

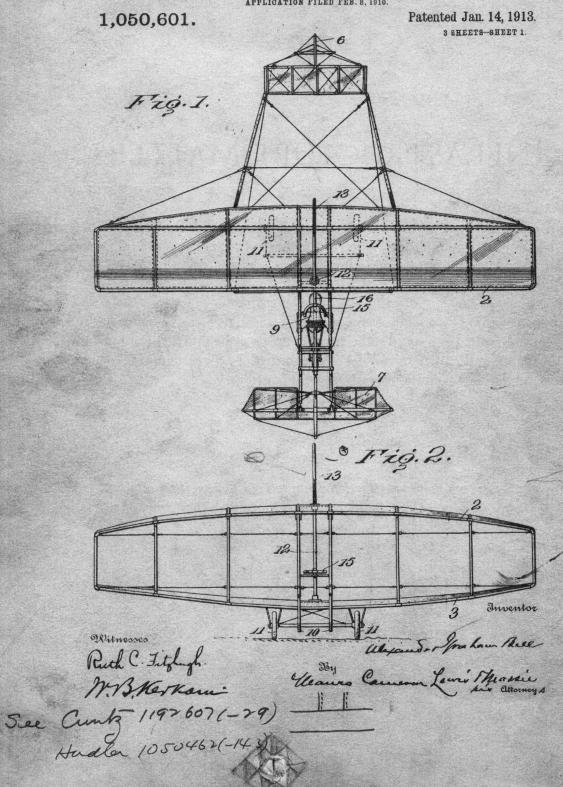

Fig. 1.

Fig. 2.

Witnesses

Ruth C. Fitzhugh.
W. B. Kerkam

See Cuntz 1192607 (-29)
Hudler 1050462 (-143)

Inventor

Alexander Graham Bell

By Mauro Cameron Lewis Massie
his Attorneys

INFRASTRUCTURE MATTERS

How do you launch and land an aircraft without a runway? Early aircraft flew at a leisurely 40 - 50 mph and landed on any open stretch of grass. Airports were still in the distant future. An efficient way was needed for planes to takeoff and land close to the city.

This 1910 tower resembles a modern construction crane and carries hooks at the end of dangling lines. Rotating at a speed sufficient to launch a plane into flight or to pluck it from the air, the cranes undoubtedly struck fear in the hearts of pilots attempting to land. The design was at least the inspiration for amusement fair rides.

Since visionaries are by definition too early, recognize what has to happen first. Build a business that solves that problem too.

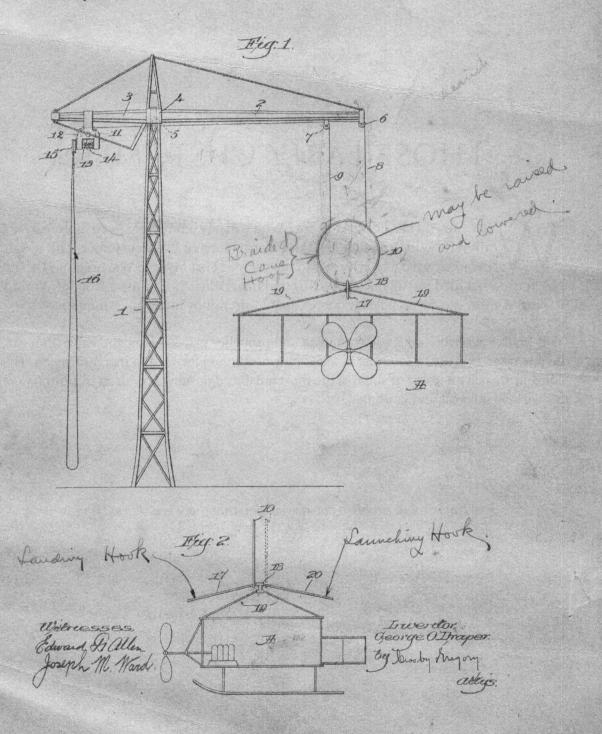

Fig. 1.

may be raised and lowered

Braided Cane Hoop

Fig. 2.

Landing Hook

Launching Hook

Witnesses.
Edward H. Allen.
Joseph M. Ward.

Inventor.
George O. Draper.
By Timothy Gregory
attys.

THOSE EARLY CUSTOMERS

What can you use an airplane for? Who will buy one? Not surprisingly, early aircraft builders focused on the government as a likely customer. The Wrights demonstrated an early craft to the army at Fort Myer in Washington, DC. Proposed uses included intelligence gathering and mail delivery. But the advent of World War I spurred efforts to develop faster, more capable aircraft by many governments.

This patent describes an auxiliary engine and propeller placed below the wings that can be positioned vertically to assist in take off or positioned forward to increase speed. This concept was an ancestor of some of the most advanced designs now used by military craft for vertical take-off and landing.

Know what problem you are solving that there is a market for.

J. F. WEBB, Sr.
AUXILIARY POWER ATTACHMENT FOR AERIAL NAVIGATING MACHINES.
APPLICATION FILED JULY 8, 1916.

1,295,648.

Patented Feb. 25, 1919.
7 SHEETS—SHEET 1.

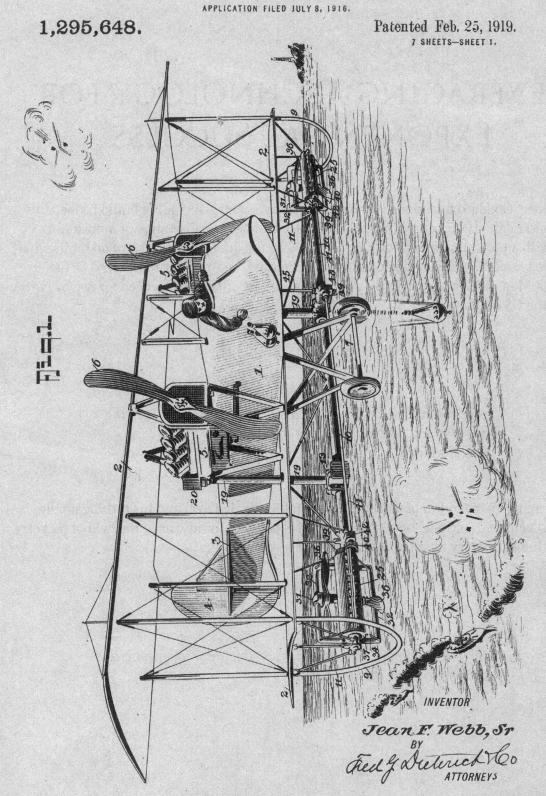

INVENTOR

Jean F. Webb, Sr

BY

Fred G. Dieterich & Co

ATTORNEYS

LEVERAGING TECHNOLOGY FOR EXPONENTIAL SUCCESS

Robert Goddard introduced many concepts to rocketry, including liquid propellants and methods of controlling trajectory. He blended the discipline of innovation with a utopian imagination characterized by the quote, 'if there were no limits what would be possible?' Often ridiculed during his lifetime, he was later recognized as the Father of Modern Rocketry. Nearly all of his 214 US Patents were licensed for use by NASA and by the US military.

"It has often proved true that the dream of yesterday is the hope of today and the reality of tomorrow."
R.H. Goddard

By leveraging an invention of a peer, Carl Gustaf Patrik de Laval and his turbine nozzle, Goddard achieved a critical breakthrough that exponentially advanced the field of rocketry, making interplanetary travel practical.

Every technology stands on the shoulders of previous attempts to solve that problem.

R. H. GODDARD.
ROCKET APPARATUS.
APPLICATION FILED OCT. 1, 1913.

1,102,653.

Patented July 7, 1914.

792,707

22

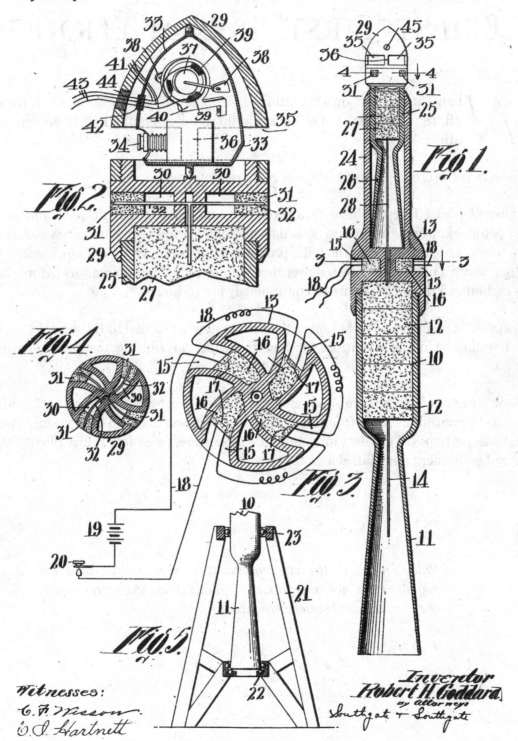

Fig.2.

Fig.1.

Fig.4.

Fig.3.

Fig.5.

Witnesses:
C. F. Wesson.
E. I. Hartnett.

Inventor
Robert H. Goddard
by attorneys
Southgate & Southgate

Being "First" Is Not Enough

When Thomas Edison's invention of the light bulb was announced on December 28, 1879, the New York Times said there were "conflicting statements of its utility."

Edison gets the credit – though there is more to the history.

English physicist Joseph Wilson Swan created a bulb in 1840 that glowed for mere minutes before expiring. Forty years passed until the invention of the mercury vacuum allowed him to evacuate the air from the bulb, producing a filament with a 13 hour lifetime. Edison bought Swan's patent, then tested over three thousand filament materials before discovering carbonized thread that burned continuously for 40 hours.

This patent is number 22 out of more than 180 patents awarded to Edison relating to electric lighting, including inventions for manufacturing, carbonizing, testing and powering lamps.

Edison's early successful inventions enabled him to attract investors such as J.P. Morgan and the Vanderbilts. Funds from these early investors were critical to the establishment of what was perhaps his greatest invention: the modern research laboratory filled with specialized equipment and skilled assistants.

Paley's maxim – the true inventor is not merely the man who registers the idea as a patent. He alone discovers who proves the purpose and satisfies the world.

(Model.)

T. A. EDISON.
Electric Lamp.

No. 239,373. Patented March 29, 1881.

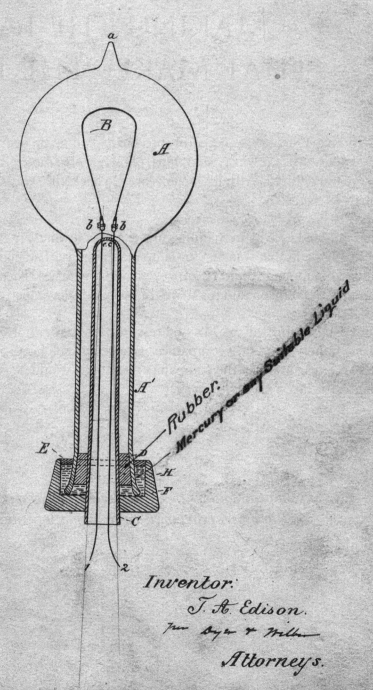

Witnesses:

B. D. Mott

James A. Rayner

Inventor:

T. A. Edison

per Dyer & Wilbur

Attorneys.



MAKING THE LAMP
THAT MAKES THE LIGHT

Thomas Edison was incredibly productive, piling up over 1000 patents in the US alone - still a record. But lamps, phonographs, motors and batteries had to be manufactured. With financiers eager to back him, why turn to others to produce his products?

Edison invested heavily in manufacturing: glass blowing, air evacuation, and filament carbonizing - and that was just for lamp manufacture. The manufacture of dynamos and switching equipment would require even larger factories. These were all manufacturing techniques that Edison and his scores of assistants developed and perfected.

Besides establishing the world's first research laboratory in New Jersey, Edison established over one hundred and fifty companies to make and sell his products in the US, Europe and South America. Many of the companies eventually would be combined, with General Electric being the largest still surviving.

Compete against business models (not companies) as then you are disrupting the very <u>basis</u> of competition.

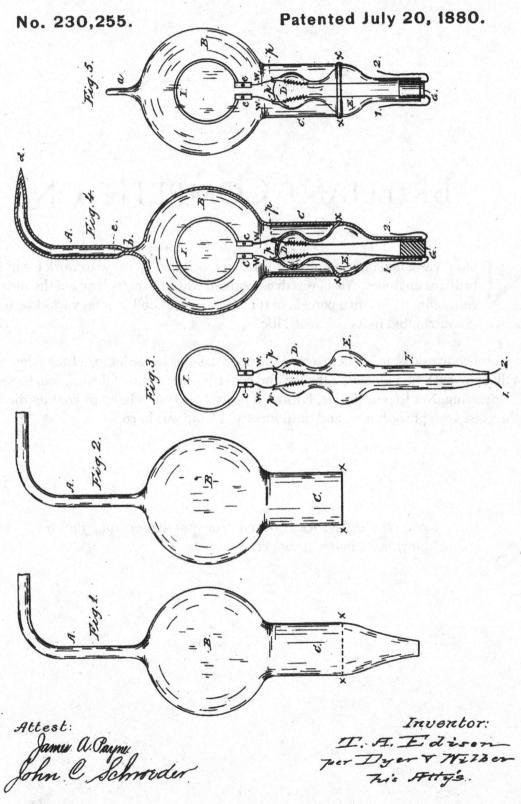

BRILLIANT COMPETITION

Nikola Tesla had once admired Edison so much that he came to work for him. A brilliant engineer, Tesla was disappointed with the inefficiency of the incandescent bulb: ninety-five percent of the incandescent bulb's energy was lost to heat which also contributed to its shortened life.

So, after leaving Edison, Tesla invented the neon gas-discharge lamp, a tube filled with a gas that glowed when ionized. Efficient and cool running, some of the original tubes are still operating. Not to be outdone, Edison improved on Tesla's lamp by coating the inside of the glass with phosphors – and the fluorescent lamp was born.

Know the difference between true innovation and just a "marginally better" product.

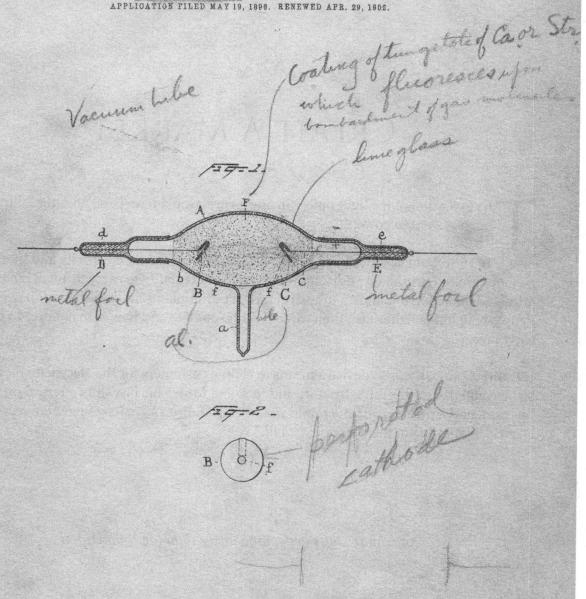

Vacuum tube

Coating of tungstate of Ca or Str. which fluoresces upon bombardment of gas molecules

lime glass

Fig-1.

metal foil

metal foil

al.

Fig-2-

perforated cathode

CREATE A MARKET

The invention of the light bulb – in any form – would have been an utter failure without a system to power it.

In 1880 homes, offices and businesses were not wired for electricity and there were no generators. Fortunately, Edison's reputation for his ability to carry through on his ideas attracted financing to build an infrastructure of power plants and a distribution network. People bought his lightbulbs, then wired their businesses and homes to connect to the early power grid.

Edison's next task was to devise a means to charge customers for the electricity they used so he could pay for his infrastructure and fuel, and to give his investors a return on their investment. Years later, Art Buchwald would quip "Edison's greatest invention was not the electric light bulb but the electric light bill."

Anticipate shifts in demand faster than the competition

T. A. EDISON.
SYSTEM OF ELECTRICAL DISTRIBUTION.

No. 438,308. Patented Oct. 14, 1890.

Fig. 3. *Fig. 4.*

Fig. 1.

Fig. 2.

ATTEST: INVENTOR:

Thomas A. Edison
By Dyer & Seely
Attys

SET THE STANDARD

The direct current (DC) form of electricity that Edison's generators produced had several shortcomings. The electricity would not travel very far without losing energy and it required thick copper wires to carry it. But its greatest disadvantage is that its voltage cannot be raised or lowered to suit different purposes.

Alternating current (AC) solved all of these problems, and was already the standard in Europe. Westinghouse promoted AC in the United States over Edison's DC and soon the two standards would lock horns until there was a winner. DC's back would be broken by several key inventions by Tesla: the AC motor, the AC generator, and most notably the power transformer that easily enabled the increase and decrease of AC voltage. Westinghouse later hired Tesla to further develop his AC inventions, and became his biggest supporter.

Standards enable you to own the infrastructure.

G. WESTINGHOUSE, Jr.
SYSTEM OF ELECTRICAL DISTRIBUTION.

No. 524,749. Patented Aug. 21, 1894.

Witnesses

James H. Smith.

Henry J. Albright.

Inventor

George Westinghouse Jr

By his Attorney

Charles A. Terry.

COMMUNICATIONS SECRETS

Of the many phenomena discovered in the 1800's, electricity itself remained one of the greatest mysteries. But a lack of understanding did not stop inventors such as Samuel Morse, a painter, who invented the telegraph (patented 1840) to send messages using code.

Barely three years after the invention of the telegraph and almost 30 years before the telephone, Alexander Bain, a clockmaker in Scotland, invented an apparatus for sending an image by telegraphy. A swinging pendulum picked up a charge from an image placed under the arc and transmitted it to a similar, synchronized arrangement that printed the image. It was the beginning of the fax machine, which would not become commercially viable for another one hundred years.

As with many inventions, this pioneering apparatus proved the theory. A commercially viable apparatus would wait for the development of the photovoltaic cell, electric motor, transducers and a number of other developments in communications, far surpassing the lifetime of the original inventor.

Bain's technique of synchronizing two clocks, one at the transmitter and one at the receiver, would become the basis for modern electronic communications. The Markey and Antheil patent of 1942 for secret communications, for example, was based on Bain's technique.

Know exactly what the real value of your product is, which is far different than what your product "does".

A. Bain.

Automatic Telegraph.

Nº 5,957.

Patented Dec. 5, 1848.

Witnesses:

Inventor:

Alexander Bain

Local Power

In the 1890's, electric power was available in very few cities and nowhere in the countryside. As electric lamps and motors became available, the need for electric power became universal.

Windmills have been used for centuries to pump irrigation water. This windmill powers a DC generator and uses a regulator as a stand-alone system to charge storage batteries for use in lighting and operating motors.

Modern windmills, now being erected by the scores, are merely the oversized children of their 120 year-old ancestors.

Turn an operating expense into a revenue stream.

J. M. MITCHELL.
WIND APPARATUS FOR GENERATING ELECTRICITY AND CHARGING SECONDARY BATTERIES.

No. 457,657. Patented Aug. 11, 1891.

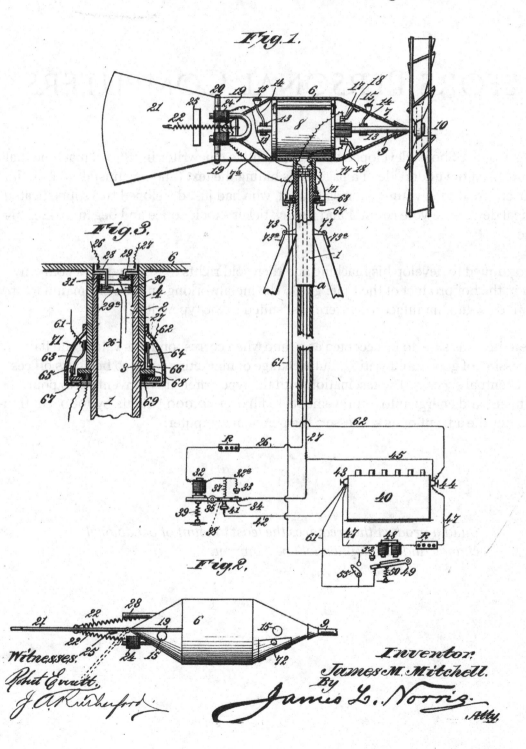

Fig. 1.

Fig. 3.

Fig. 2.

Witnesses:
Robt Ervatt,
J. A. Rutherford

Inventor:
James M. Mitchell
By
James L. Norris,
Atty.

BEFORE PERSONAL COMPUTERS

Christopher Sholes developed the first primitive typewriter in 1868, a machine that wrote on the underside of a page, thus hiding the text (and any mistakes) from its user. By 1871, a young Thomas Edison, who had just developed two sophisticated mechanical devices - a vote counter and a stock ticker - took notice and began to offer his assistance.

Sholes continued to develop his machine and then sold rights to Remington, a company engaged in the hot product of the time: guns. The metalworking and precise manufacturing required by gun manufacturing were well suited to the typewriter.

The typewriter was slow to be accepted at a time when correspondents valued the flair and expression of good handwriting. But a change of marketing focus to business offices brought eventual success. The fascination with the typewriter drove inventors to pour enough talent and energy into improvements to fill over 40,000 patents by 1980, continuing well after the advent of its successor: the personal computer.

Build a product that requires the least amount of behavioral change and its adoption will be rampant.

15-1

Fig. 1

Fig. 6

Fig. 7

Fig. 4

Fig. 5

Fig. 2

Fig. 3

Witnesses Inventor:

Henry J. Arch C. Latham Sholes
Henry A. Johnston By
 by James Densmore

 his Agent

Avoid The Entrepreneurial Trap

Mark Twain loved inventions. He was not as technically proficient as the inventors he admired, but he did invent a game and a scrapbook. In the late 1800's, Twain became enamored of a typesetting machine that could mechanically compose the individual letters of type for printing newspapers 4-16 times faster than by hand. With over 18,000 parts, the machine was fragile and prone to repeated failure. Twain saw a big market and continued to pour money into the venture.

At the same time, a slightly slower but more dependable machine, the Mergenthaler Linotype, (shown here) was already on the market. It was well supported by its company and soon dominated the market. Twain had invested over $200,000 over a period of eleven years supporting the more complicated competitor before suddenly calling a halt to his efforts. Only one of the Twain-supported machines still survives.

Fail early, fail often! Then know when to move on.

F. E. BRIGHT
TYPOGRAPH.

No. 557,184.

Patented Mar. 31, 1896.

Swedish 3529 - 90

Fig.1

Melting Pots
Molds & Cutters
Matrices
Justifying Devices

WITNESSES:
Victor J. Evans.
J. C. Turner.

INVENTOR:
F. E. Bright
By *Hall and Fay*
HIS ATTORNEYS.

Timing Your Market

The photocopier may have at one time been considered a modern invention, but it took most of its inventor's lifetime to develop. (The first commercial machine was sold in 1959). Chester Carlson, a young physicist and patent attorney, began work in 1935 on the process of electrophotography. His motivation was partly to make his own job of creating multiple copies of patent applications easier.

After several technical breakthroughs, he turned to a number of companies for additional funding. GE, RCA, IBM and the US Signal Corps, not seeing a market need for dry copies, all turned Carlson down.

Finally, in 1944 Battelle Memorial Institute convinced the Haloid Company to sponsor the needed development. It would take another fifteen years (and a name change to Xerox) before the first easy to use photocopier hit the market: the Model 914. In its first six months the 914 exceeded sales projections for the entire lifetime of the machine.

If you're going to build a "disruptive" product, first make sure there's a market to disrupt.

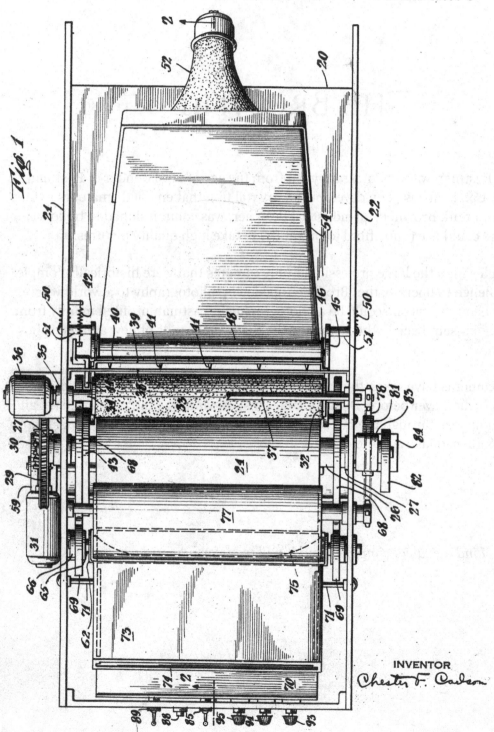

Fig. 1

INVENTOR

Chester F. Carlson

THE BROWNIE

George Eastman was a photography fan from the age of 20. Founder of Eastman Kodak Co., he focused on developing a dry roll film that enabled amateurs to take photos. Frank Brownell, an industrial designer, was commissioned to build a camera that anyone could use (and afford to buy at $1) to take high quality pictures.

Radically simpler than the large professional-only cameras that were historically complex and a real challenge to operate, the "Brownie" opened up photography to a world where, in Eastman's vision, "everyone could be a photographer". Eastman profited mainly from processing the film sent back to the factory by the many thousands of new amateur photographers.

Today digital cameras have taken the baton from the Brownie camera, putting a camera into more hands than ever before. Digital enables instant viewing (and correction) of an image, sharing images through the Internet, and it removes the penalty of cost-per-photo in deciding whether to take a photo or not.

Find a radical simplifier and it will transform an industry.

No. 684,347.

Patented Oct. 8, 1901.

F. A. BROWNELL.
FINDER FOR PHOTOGRAPHIC CAMERAS.
(Application filed Feb. 7, 1901.)

(No Model.)

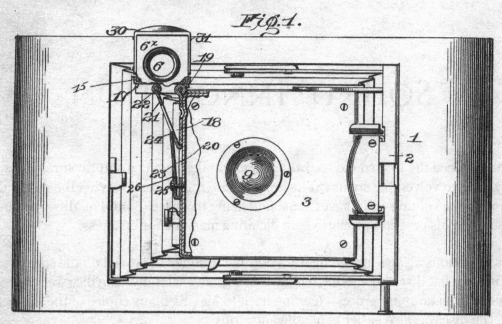

Fig. 1.

7575

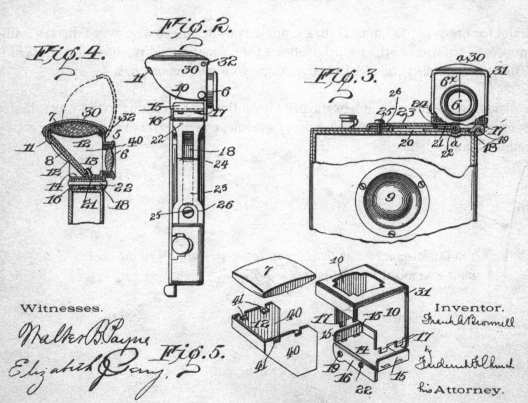

Fig. 2.

Fig. 4.

Fig. 3.

Witnesses.

Walter B. Payne

Elizabeth J. Gary

Fig. 5.

Inventor.
Frank A. Brownell
by
Frederick A. Church
his Attorney.

A "Sound" Innovation

Edison produced the first sound recording on a cylinder having a soft tin surface. As the cylinder revolved the stylus cut its grooves into the surface, varying the depth according to the volume and tone of the sound being recorded. Sound quality was not great. Edison saw his creation primarily as a dictating machine for business.

Significant inventions always lure competitors. Emile Berliner improved on the sound quality by using a flat disc and varying the inscribed groove laterally. The disc was easily reproduced in a stamping process, lending itself to making many copies of the same recording. The disc was also easier to handle and store.

The demand for pre-recorded music quickly singled out Berliner's disc over Edison's cylinder (by now made of wax) as the record of choice for its sound quality, durability and ease of use. The only capability the disc lacked: making your own recordings.

Edison considered the phonograph his favorite invention. Yet, he clung to the wax cylinder as the recording medium for many years past its prime, convinced that its recording capability would win an audience.

Innovation success is delivering what <u>customers</u> want, not what you want to sell them.

E. BERLINER.
GRAMOPHONE.

No. 564,586.

Patented July 28, 1896.

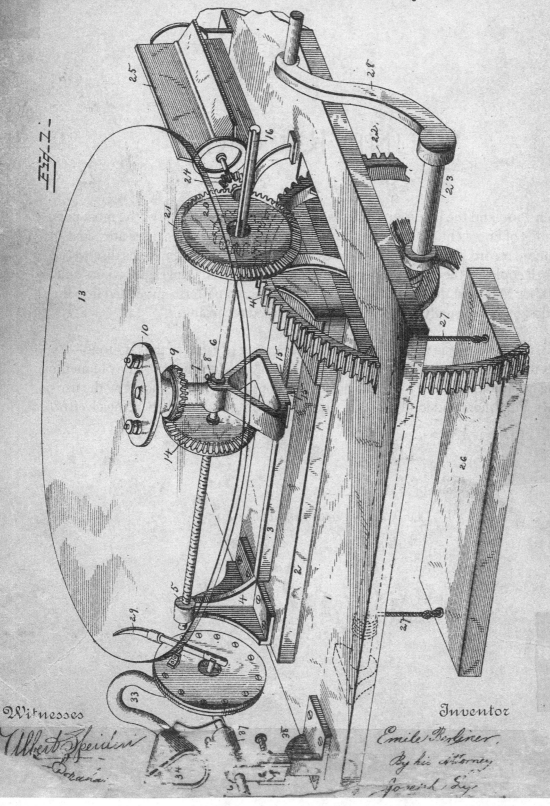

Witnesses

Albert Speiden

Inventor

Emile Berliner

By his Attorney

Joseph Say

SOUND RECORD

Between 1900 and the late 1920s, the disc phonograph became one of the most popular forms of home entertainment. The public's appetite for music discs attracted legitimate record shops as well as pirates. Bootleg recording companies discovered they could sell copies of the original without the associated costs. Copyright owners quickly sought methods to thwart the practice. The disc at right has a pattern embedded into the blank disc designed to visually identify it as an authorized recording.

The boom in recorded music was cut short with the coming of radio in the late 1920s. As record sales fell, inventors countered by improving recording technology. The old method of recording by shouting directly into the horn of a phonograph was replaced by the use of microphones, amplifiers and loudspeakers. Sound recording had finally become electronic.

Look for opportunity in chaos

J. W. OWEN.
SOUND RECORD FOR TALKING MACHINES.
APPLICATION FILED AUG. 27, 1907.

964,685.

Patented July 19, 1910

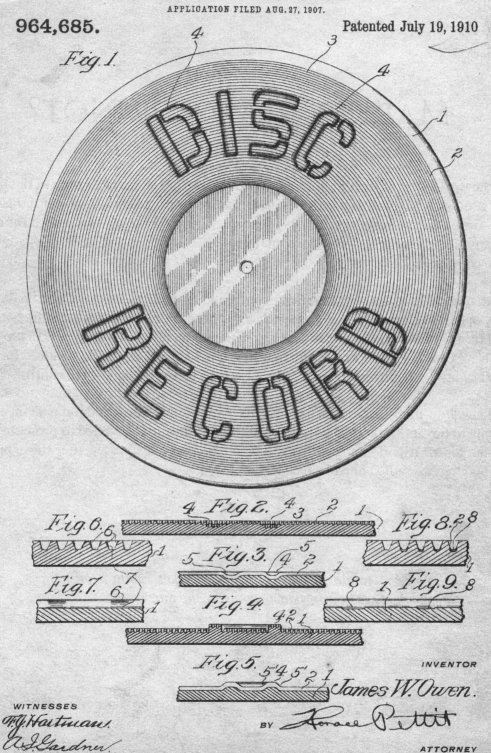

WITNESSES
F. J. Hartman.
A. S. Gardner.

INVENTOR
James W. Owen.

BY Horace Pettit

ATTORNEY

MARKET READY OR NOT?

The world would be a different place without the presence, beginning in the late 1800's, of Nikola Tesla. After transforming the entire electrical power industry, he turned his interests to radio. Radio was hardly known to anyone before 1900 and Tesla was already sending signals over many miles. To demonstrate radio, Tesla invented remote control.

The patent at right is the very first radio-controlled vehicle. Six feet long, the boat had a battery operated electric motor, an electrically moved rudder and electric lights – all controlled by a handheld radio - in 1898. The phenomenon of radio was so new that observers at the New York Expo suspected supernatural forces at work as the boat moved forward left and right; lights turning on and off, in response to Tesla's hand-held control.

Tesla knew how many uses there were for his invention. But he could not convince even the Army to buy it. Mark Twain – that great lover of inventions – tried to promote the invention for his friend, but to no avail. It would be many years, long after the expiration of the patent, before radio control would be employed.

Ask the tough questions. Is the market ready for your product? Is your product ready for the market?

No. 613,809.

Patented Nov. 8, 1898.

N. TESLA.

METHOD OF AND APPARATUS FOR CONTROLLING MECHANISM OF MOVING VESSELS
OR VEHICLES.

(No Model.)

5 Sheets—Sheet 1.

Fig. 1

See Figs. 4, 6, 7, 8.
Cylinder C rotates 180°
by means of an electro-
magnet and a clock
train. During rotation,
the resistance material d
within cyl. c acts to
interrupt current and
said material d is
so made as to give
the same resistance
value no matter which
end of the cylinder is
down.

Witnesses:

Raphaël Netter

George Scherff.

Inventor

Nikola Tesla

Wireless Magic

Marconi is credited with the invention of radio-telegraphy in the 1890's. But others including Tesla were already actively involved in transmitting signals through the air.

Communication was based on producing a high voltage spark at the transmitter that caused a "disturbance in the air." The signal could be detected by a "coherer," a small simple device whose oxide particles would line up when exposed to the disturbance, even at great distance. Unfortunately, early systems could not be tuned. The signal was available for all receivers nearby to detect and multiple transmitters interfered with each other.

Many inventors had experimented with the phenomenon and Marconi borrowed heavily from their accomplishments. Marconi was credited with developing the components into a practical communications system based on telegraphy that, among other uses, soon enabled ships to have their first means to transmit "S.O.S." from great distances at sea.

By the time Marconi brought his system to America, he found that Tesla's work had pre-dated much of his own and the courts overturned a number of Marconi's patents. Nonetheless, key patents survived and he founded the Marconi Company.

Know what the rest of the world is doing. Even if you already have a patent on a product, evidence of an earlier occurrence of that product can upset all of your plans.

G. MARCONI.
TRANSMITTING ELECTRICAL SIGNALS.

No. 586,193.　　　　　　　　　　　Patented July 13, 1897.

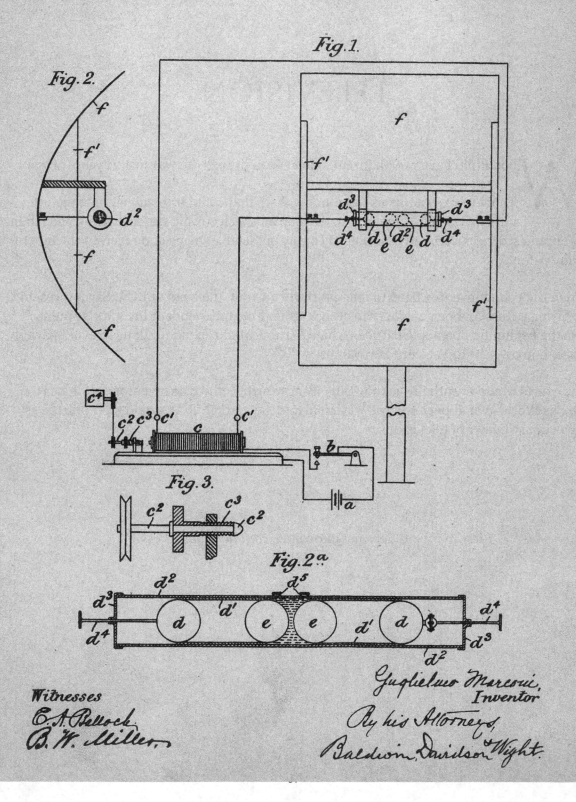

Witnesses
C. A. Pollock
B. W. Miller

Guglielmo Marconi,
Inventor
By his Attorneys,
Baldwin Davidson & Wight.

TELEVISION

When Philo Farnsworth invented television in 1927, he was just 21 years of age.

There were systems using spinning discs that could transmit a crude picture, but Farnsworth's goal was to develop an all-electronic system. In a small lab in San Francisco, he succeeded in producing a tiny but legible image and received the first of many patents.

When the young inventor tried to interest David Sarnoff, the head of RCA, Sarnoff reacted by hiring a Russian born engineer to design around the independent inventor's patent. It was the beginning of an epic battle in which Sarnoff would spend millions to avoid paying a non-employee of RCA a cent in royalties.

The courts would eventually acknowledge Farnsworth as the true inventor, but it was too late: as World War II began Farnsworth had lost the market. RCA would later emerge as the primary maker of televisions.

First to invent does not guarantee commercial success.

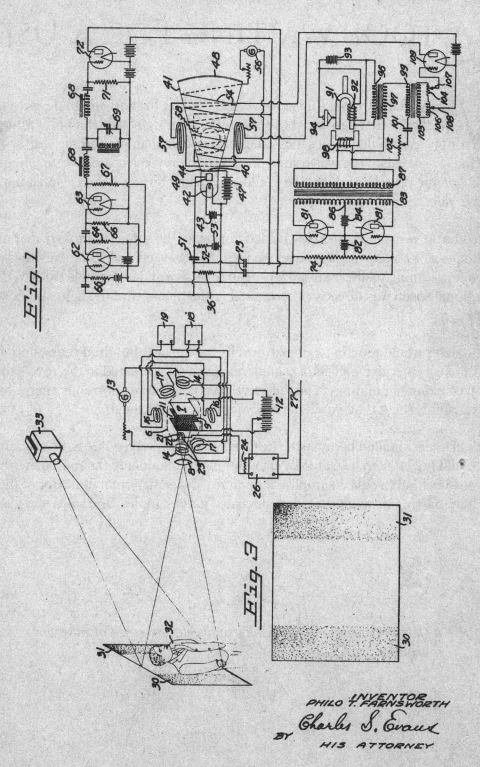

Fig.1

Fig.3

INVENTOR
PHILO T. FARNSWORTH

BY Charles S. Evans

HIS ATTORNEY.

A Tool Waiting For A Use

When William Crookes invented the radiometer in 1876, his goal was to test the theory that light exerts a force that can be detected. His brilliantly simple apparatus balanced a set of vanes on a needle that allowed the vanes to freely rotate. One side of each vane was coated black and the reverse coated white. Photons impinging on the reflective white side would exert a greater force than against the black, absorptive side.

To overcome air resistance, Crookes availed himself of the same technology that made the light bulb possible: a blown glass envelope with the air evacuated. Suddenly the vanes came to life, spinning to alternately expose the reflective and absorptive sides to the light. The rotational speed was directly proportional to the intensity of the light shining on the apparatus.

The radiometer would remain a popular novelty for the next hundred years, until another new technology emerged: e-glass, a coated, reflective glass created in the 1970's to save energy in glass skinned buildings. The reflective glass could save enormous energy by reflecting the sunshine's heat that would normally pass straight through.

But sales of e-glass stalled because the heat reflective property, while easily measured in the lab, could not be demonstrated by the sales people. Suddenly the radiometer had a use: when placed behind the glass samples, it became a dramatic visual indicator of the difference in light passing through coated vs. uncoated glass samples, and sales of e-glass took off.

Design a product specifically to accelerate sales of another product.

W. CROOKES.
APPARATUS FOR INDICATING THE INTENSITY OF RADIATION.
No. 182,172. Patented Sept. 12, 1876.

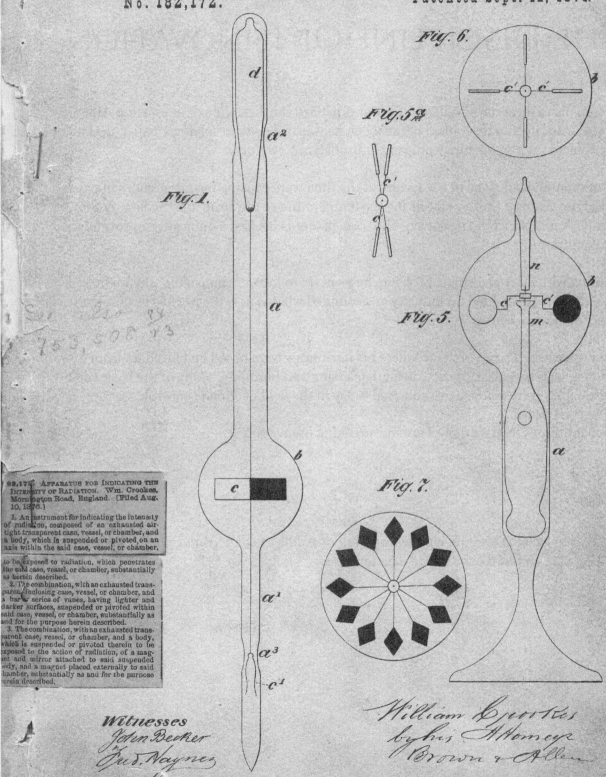

Fig. 1.

Fig. 6.

Fig. 5ª

Fig. 5.

Fig. 7.

See also 74
753,500 83

82,172. APPARATUS FOR INDICATING THE INTENSITY OF RADIATION. Wm. Crookes, Mornington Road, England. [Filed Aug. 10, 1876.]

1. An instrument for indicating the intensity of radiation, composed of an exhausted air-tight transparent case, vessel, or chamber, and a body, which is suspended or pivoted, on an axis within the said case, vessel, or chamber, to be exposed to radiation, which penetrates the said case, vessel, or chamber, substantially as herein described.

2. The combination, with an exhausted transparent inclosing case, vessel, or chamber, and a bar, a series of vanes, having lighter and darker surfaces, suspended or pivoted within said case, vessel, or chamber, substantially as and for the purpose herein described.

3. The combination, with an exhausted transparent case, vessel, or chamber, and a body, which is suspended or pivoted therein to be exposed to the action of radiation, of a magnet and mirror attached to said suspended body, and a magnet placed externally to said chamber, substantially as and for the purpose herein described.

Witnesses
John Becker
Jud. Wayne

William Crookes
by his Attorneys
Brown & Allen

The Discipline Of Innovation

From his earliest days, Willis H. Carrier practiced the discipline of innovation. His pivotal work in climate control began when he was tasked with solving a paper alignment problem for a publishing company in Brooklyn, New York.

Environmental conditions in the factory at the time were causing inconsistencies in paper size. Carrier realized that by stabilizing the temperature of the air inside the factory the alignment problem would be solved. The 1906 patent is his first significant improvement in air conditioning.

Beginning with solving a single problem, he went on to forever change the way we live, work and play. He created an industry and founded what is now the world's largest manufacturer of climate control equipment.

Carrier established a research lab where his inventions were based on hard data from disciplined research of airflows, dew point depression and humidity. Many of the basic scientific principles he developed are still used today in the field of climate control.

Carrier continues its tradition of ground-breaking innovation.

Use a well-disciplined process of problem-solving and you can make the world a better place.

No. 808,897.

PATENTED JAN. 2, 1906.

W. H. CARRIER.
APPARATUS FOR TREATING AIR.
APPLICATION FILED SEPT. 16, 1904.

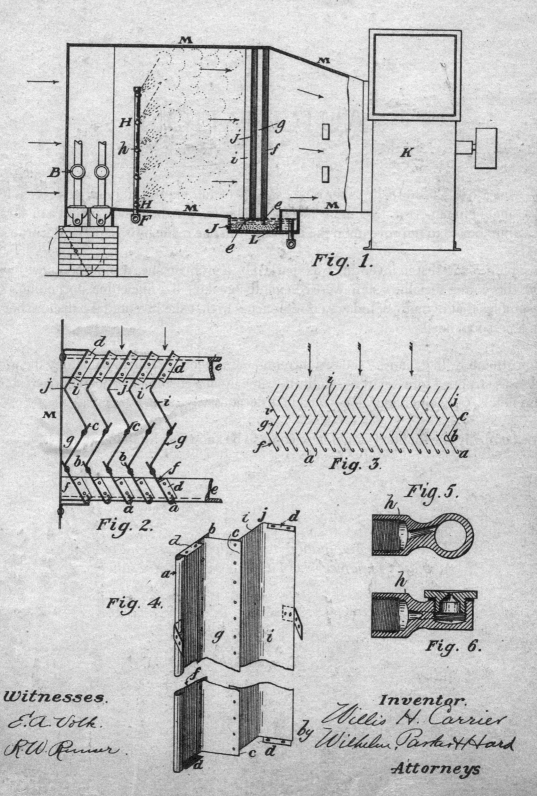

Fig. 1.

Fig. 2.

Fig. 3.

Fig. 4.

Fig. 5.

Fig. 6.

AUTOMATION

Lina Sloan's 1888 Dishwasher is an example of automating an iterative process to eliminate human error. Like many inventors, she was not the first to invent a dishwasher, but looked to improve upon the first practical one made by Josephine Cochran.

Josephine's interest in inventing was sparked by a problem she recognized in her own life: this young socialite's staff were constantly breaking her fine china. Josephine's story resembles that of many of today's entrepreneurs in that she invented the dishwasher based on a personal need.

Unfortunately, like many of today's entrepreneurs, when it came to launching the product she was strapped for resources - until she came upon a customer in need: large restaurants and hotels. Consumer adoption would take decades.

The company she founded would later come to be known as KitchenAid.

Innovate by automating an iterative process and market it to those companies where it removes a "reverse salient".

L. SLOAN.

DISH WASHER.

No. 393,671.　　　　　　　Patented Nov. 27, 1888.

Fig.1.

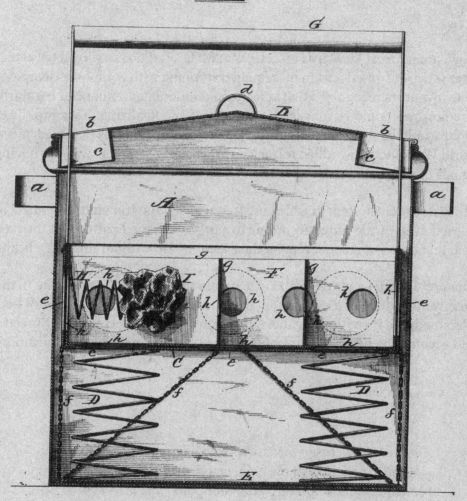

WITNESSES.

G. S. Elliott.

C. H. Cummings

INVENTOR.

Lina Sloan.

per Chas. H. Fowler

Attorney.

WIRELESS BY NATURE

Hedy Lamarr, best known as an actress at MGM, did not study electrical engineering, yet co-invented a form of frequency hopping with composer George Antheil. The inventors recognized that voices could modulate frequencies regularly and theorized radiowaves could be managed in the same way. Realizing that a rapidly changing frequency would be nearly impossible to jam, her invention was designed at the beginning of World War II to allow Allied torpedoes to reach their targets without having their control signals blocked.

Together they devised a system in which the frequency of the transmitted control signal could be varied over a wide range according to a predetermined pattern. If the receiver could match that pattern, it could receive the transmission without missing a beat.

Using a "piano roll" from a player piano to generate the code, and a duplicate in the receiver, the two inventors created a system that could not be detected or jammed. When finally it was understood, the invention became more than a wartime technology. Spread spectrum would become the heart of cellular, satellite and other digital communications.

Analyze with laser-focus the root of a problem, look for where in the universe the answer exists naturally and look to replicate that design into your solution.

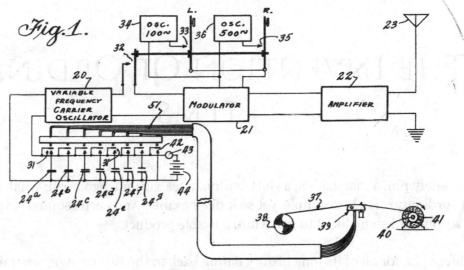

Fig.1.

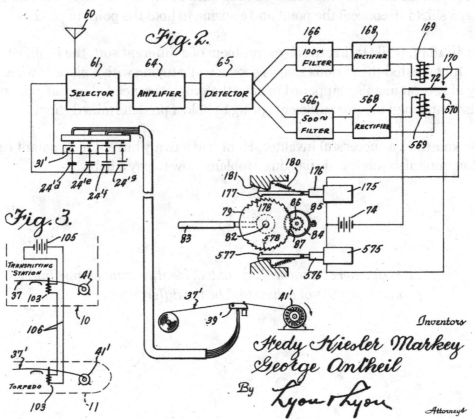

Fig.2.

Fig.3.

Inventors

Hedy Kiesler Markey
George Antheil

By

Lyon & Lyon

Attorneys

THE INVENTION OF ORDINARY ITEMS

A safety pin, a matchstick, a shirt-button, a teabag and a golf ball: what could be more ordinary? Each so simple, yet so indispensable. And each required experimentation (and some luck) to make into a usable product.

The safety pin, for all of its long history dating back to the Bronze Age, was missing two features: a shield to conceal the point and a spring to hold the point in place.

One day in 1849, while trying to solve a problem of a different sort, the prolific inventor Walter Hunt created the various shapes shown while toying with a piece of wire. The wire, an alloy of several metals, happened to have the properties needed to make the pin rigid, yet it also happened to have sufficient spring to hold a predetermined shape.

Already known as a successful inventor, Hunt had a ready buyer for all patent rights to his invention, thus also solving his nagging problem: how to pay a debt.

Look at where a market is crowded, identify what compelling problem is <u>still</u> not solved and be the differentiator.

W. Hunt.
Pin.
Nº 6281. Patented Apr. 10. 1849.

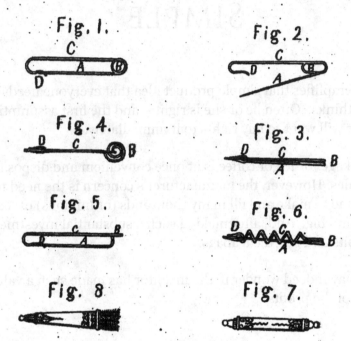

Fig. 1.

Fig. 2.

Fig. 4.

Fig. 3.

Fig. 5.

Fig. 6.

Fig. 8

Fig. 7.

SIMPLE

The tea bag exemplifies that simple product idea that everyone needs or wants, or so the inventor thinks. Often he or she is right – and the first assumption is that any manufacturer will want to buy rights to it immediately.

A single serving package for tea or coffee is at once convenient and disposable, guaranteeing continuing sales. However, the manufacturer's concern is the need for a unique, million dollar machine to make and fill many thousands (or millions) of tea bags that could also attach a string and tag. And, after making such a substantial investment, will consumers change their habits and buy the teabags.

The manufacturer may indeed wonder if the inventor has made such a valuable contribution to deserve part of the profits.

How many other inventions will your invention inspire?

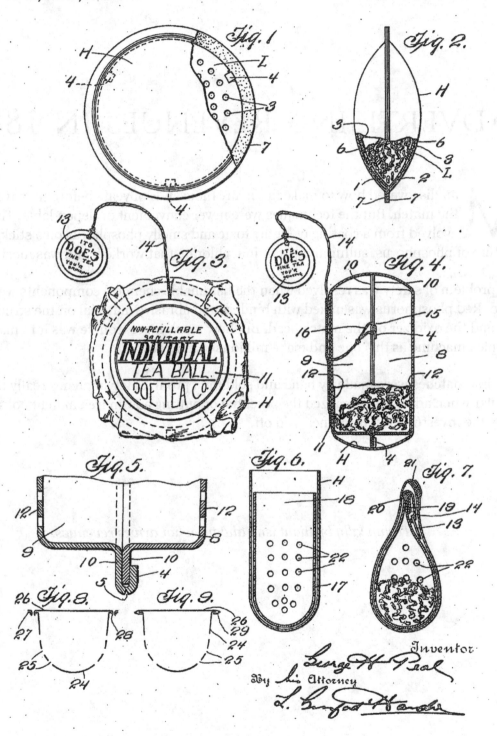

Advertising Revenues in 1889?

Man discovered how to make fire many thousands of years before the invention of the match. But the techniques were never convenient or dependable. The match evolved from a coating of highly toxic and smelly phosphorus on a stick, to a mixture of phosphorus, sulfur and potassium chlorate that worked, and was mostly safe.

The problem of safety was resolved when the flammable chemical components were separated. Red phosphorus was mixed with binders and abrasive material on the striking surface and the oxidizer on the match head. But how much more trouble was it to make such a complex machine as this one and make millions of matches?

The first matches were made by hand and sold for a profit. Safety matches really became popular when advertisers realized the potential of putting ads on free matchbooks. Suddenly the investment in machines paid off.

Technically brilliant isn't always what drives revenues.

G. E. NORRIS & W. E. HAGAN.
MATCH MAKING MACHINE.

No. 332,737.

Patented Dec. 22, 1885.

Fig. 1

WITNESSES:

Stanley M. Holden.

Charles S. Bruntnall

George E. Norris

William E Hagan INVENTORS

BY

W E Hagan ATTORNEY

SUCCESS BY DESIGN

The buttonhole is as old as the button. But how do you make thousands of buttonholes, with the sewn reinforcement around the perimeter of each, and still sell a shirt for a reasonable price? One machine could replace a dozen seamstresses and produce a finished product that was affordable with consistent quality.

The demand for skilled machine designers and makers was high enough during the industrial revolution that companies specialized in making the machines used by other companies to make products. Many of those machines were so well made they are still in use exactly as made a hundred years later.

Nothing works as effectively as a purpose-built solution.

J. G. GREENE & L. F. A. BÜCHNER.
BUTTONHOLE CUTTING MECHANISM.
APPLICATION FILED DEC. 13, 1910.

1,035,344.

Patented Aug. 13, 1912.
3 SHEETS—SHEET 1.

Fig. 1.

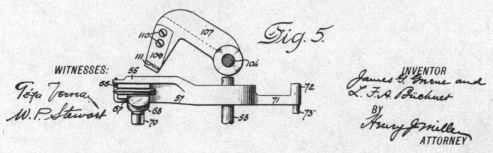

Fig. 5.

WITNESSES:
Péfa Terra
W. P. Stewart

INVENTOR
James G. Greene and
L. F. A. Büchner
BY
Asury J. Miller
ATTORNEY

Processed to Perfection

Ever wonder how a golf ball or a ping-pong ball is made? A patent is one of the most detailed sources of information on the process. Handmade balls in the 1800's suffered from lack of uniformity and balance. Processes to make balls by machine evolved over fifty years to provide the proper characteristics for each sport and the consistency necessary for play.

The patent for making a golf ball was one of a series of patents that covered each new step that was invented. Rubber was the dominant material used in balls at the turn of the century. Plastic was still years from being discovered. As new synthetic materials and improved molding techniques evolved, they significantly improved playability especially of multilayer balls.

Watch for innovations in other industries that will create a new opportunity in your industry.

F. H. RICHARDS.
GOLF BALL.
(Application filed Mar. 24, 1902.)

(No Model.)

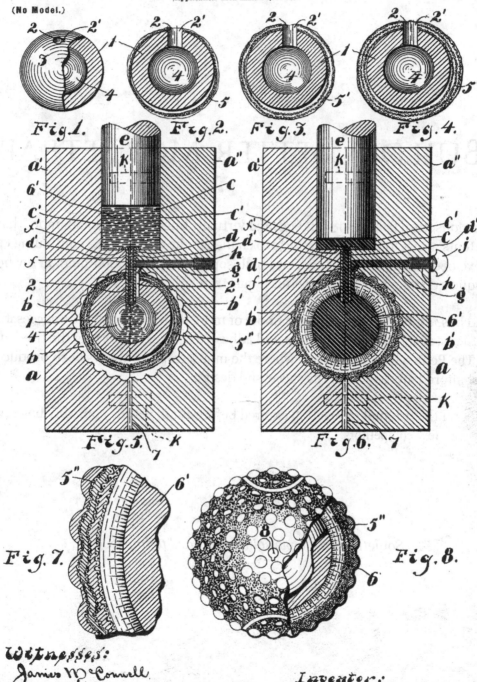

Fig.1. Fig.2. Fig.3. Fig.4.

Fig.5. Fig.6.

Fig.7. Fig.8.

BUILD A BETTER MOUSETRAP

The mousetrap from 1898 has endured virtually unchanged, though more than 4,000 patents attest to inventors' efforts to challenge the design. The continuing efforts have been blamed on the poet and philosopher Ralph Waldo Emerson – who has been misquoted as saying "build a better mousetrap ..."

The world has *not* beaten a path to the doors of more than twenty slightly successful alternative designs, including electrocution and adhesive devices, preferring the tried and true original. The Pennsylvania company where the mousetrap has always been produced has wisely not altered any aspect of the successful design.

The patent on the original mousetrap expired before 1920, yet the company has continued to prosper with few competitors.

Sometimes a simple solution is hard to improve on.

No. 744,379.

PATENTED NOV. 17, 1903.

J. M. MAST.
ANIMAL TRAP.
APPLICATION FILED OCT. 30, 1899.

NO MODEL.

2 SHEETS—SHEET 1.

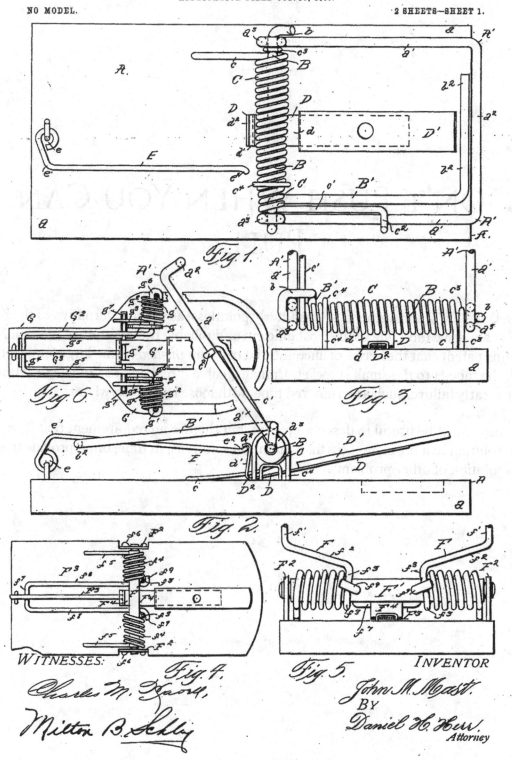

Fig. 1.

Fig. 6.

Fig. 3.

Fig. 2.

Fig. 4.

Fig. 5.

WITNESSES:

Charles M. Knorr,

Milton B. Schley

INVENTOR

John M. Mast,
BY
Daniel H. Herr,
Attorney

DON'T PUSH WHEN YOU CAN PULL

Sometimes an "improvement" seems utterly pointless, as in this alternative to the bicycle chain drive (still one of the most efficient and reliable transmitters of power). Note in this patent that the series of unconnected balls are *pushed* by the large sprocket through the tube H to the small sprocket. Unmanageable forces and friction losses almost guarantee early failure, such as a ruptured tube, with loose balls everywhere.

An invention must be useful to deserve a patent, but there is no requirement that it provide the best solution to a problem. Less than optimum solutions, in time, often provide useful leads to solution of other problems.

C. L. THOMAS & J. O'CONNELL.
POWER TRANSMITTING MECHANISM.

No. 585,135. Patented June 22, 1897.

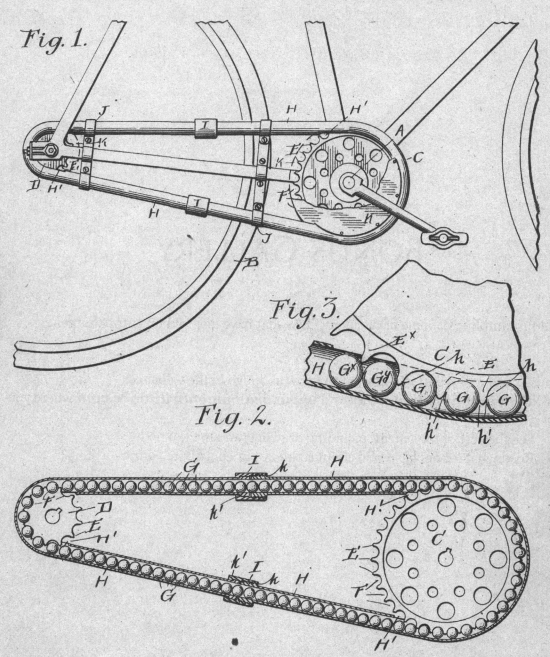

Fig. 1.

Fig. 3.

Fig. 2.

Witnesses.
G. M. Andrson
P. O. Illasi.

Inventors
C. L. Thomas
Jno. O'Connell
By E. W. Anderson
Their Attorney

Bonus Gallery

A random sampling of some of the many ideas that have inspired inventors for generations.

When you find an invention you want to know about go to the websites:
www.drawingonbrilliance.net and ***www.drawingonbrilliance.com*** where you can:
- See the rest of the patent, including drawings and the full text.
- Read what others have said about a patent (or contribute your own story).

E. D. LEAVITT, Jr.
Improvement in Steam-Pumping Engines.

No. 129,240. Patented July 16, 1872.

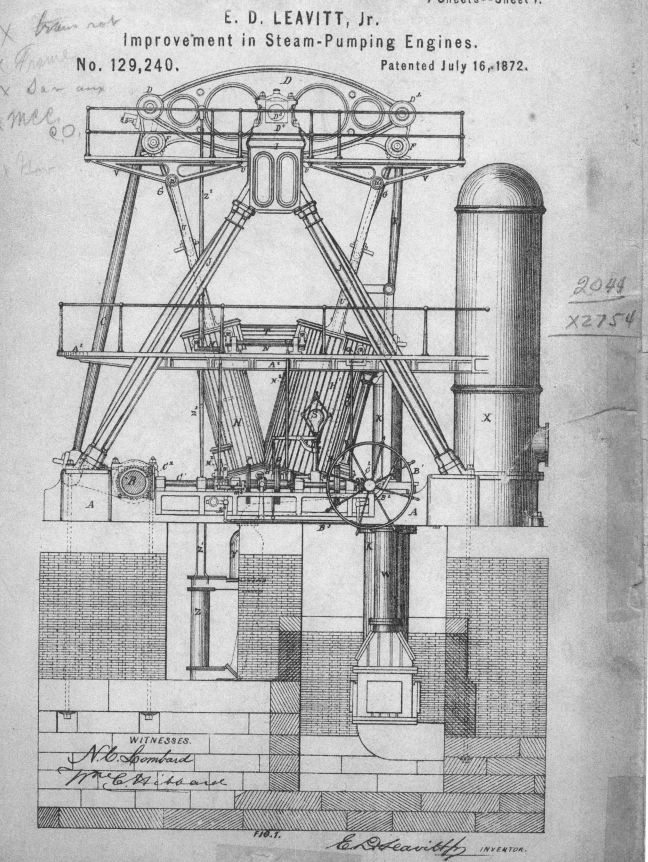

FIG. 1.

WITNESSES.

N. C. Lombard

Wm C. Hibbard

C. D. Leavitt, INVENTOR.

41

punching, & creasing,
Reciprocating jaw or die block;
Reciprocating punch & creasing.

Sheet 1 - 2 Sheets.

Griffiths & Shields,

Horseshoe Machine.

Nº 12,112.

Patented Dec. 19, 1854.

Fig. 1.

No. 640,968.

Patented Jan. 9, 1900.

E. A. SPERRY.
ELECTRIC VEHICLE.
(Application filed Aug. 19, 1898.)

(No Model.)

2 Sheets—Sheet 1.

Controller position on T''
1. Opens main cct, for amps blade.
2. Controls charging
3. Isolates || and series || contacts when disconnects battery from main cct.

Motor may become a generator

Drill 396,222 Septime Battery
Crowdus 396,314
See Hunter 384,910

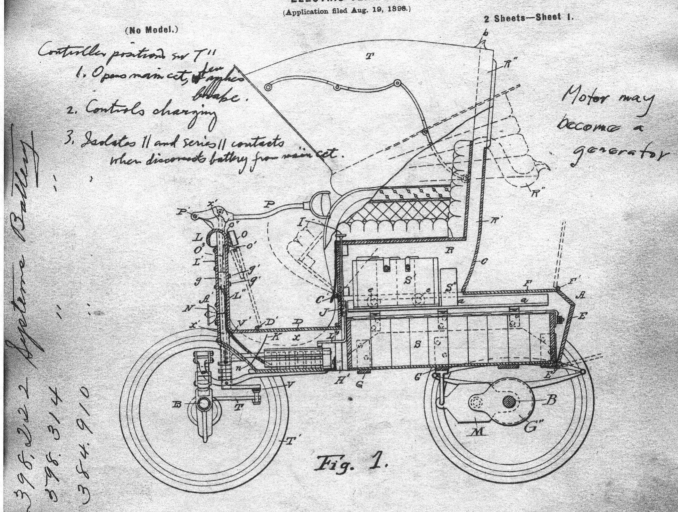

Fig. 1.

B. B. GOLDSMITH.
METHOD OF MAKING RUBBER BANDS.
APPLICATION FILED AUG. 1, 1911.

1,189,936.

Patented July 4, 1916.
2 SHEETS—SHEET 1.

Fig. 1.

Fig. 2.

Fig. 3.

Byron B. Goldsmith
Inventor

By his Attorneys
Wilkinson, Fisher, Witherspoon and MacKaye

Witnesses;
Edward Rowland.
A. M. Martin

No. 648,660.

Patented May 1, 1900.

R. A. FESSENDEN.
X-RAY APPARATUS.
(Application filed Aug. 7, 1899.)

(No Model.)

Tr663

E. S. CONVERSE.
Improvement in Shoes.

No. 115,169.

Patented May 23, 1871.

FIG.1.

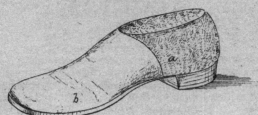

FIG.2.

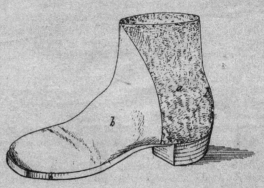

FIG.3.

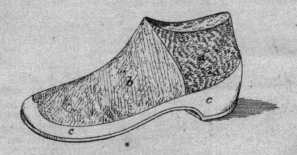

Elisha S. Converse
by his attorney

A Pollok

WITNESSES. C. B. Nottingham
S. M. Pobe

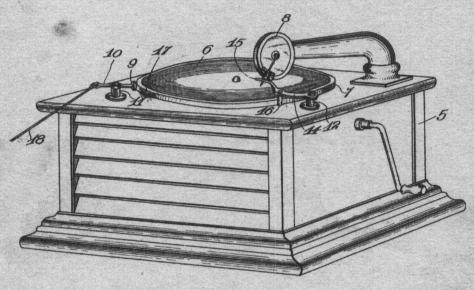

Fig. 1.

Fig. 2.

Axel Stahl.
Inventor

Witnesses
H. J. Batchelor
S. J. Lehrer

by
Milo B. Stevens & Co.
Attorneys

June 4, 1929.

L. DE FOREST

1,716,033

METHOD OF PRODUCING TALKING MOTION PICTURE
FILMS AND APPARATUS USED THEREFOR

Filed June 7, 1924 2 Sheets—Sheet 1

Method Claims

ADDING SOUND TO SILENT
PICTURES BY PROJECTING
SILENT PICTURE & HAVING
SOMEONE READ THE LINES
IN PROPER SYNCHRONISM
WITH PICTURE. THE SOUND
IS RECORDED & THEN A
COMPOSITE POSITIVE IS
MADE OF THE SOUND &
PICTURE NEGATIVES
AS SHOWN IN FIG. 1.

For projecting silent
pictures and simultaneously
recording appropriate sound.
See Fig 2

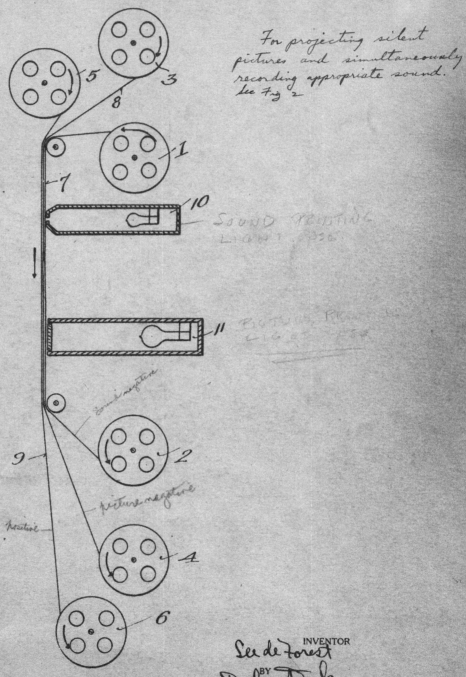

SOUND PRINTING
LIGHT 930

PICTURE PRINTING
LIGHT 931

Sound negative

picture negative

Fig. 1 positive

INVENTOR
Lee de Forest
BY
Darby & Darby
his ATTORNEYS

See DeForest 1,888,910 88/16.2 XRef filed same day
" " 1,764,938

T. A. WATSON.
Microphonic Telephone.

No. 242,723. Patented June 7, 1881.

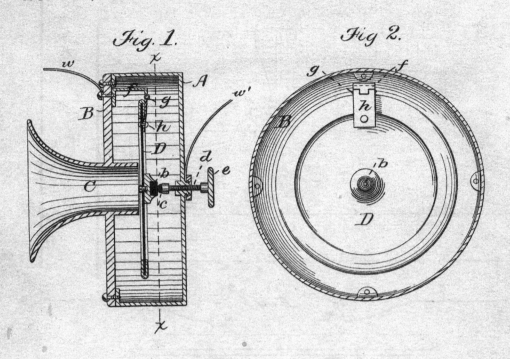

Fig. 1. Fig 2.

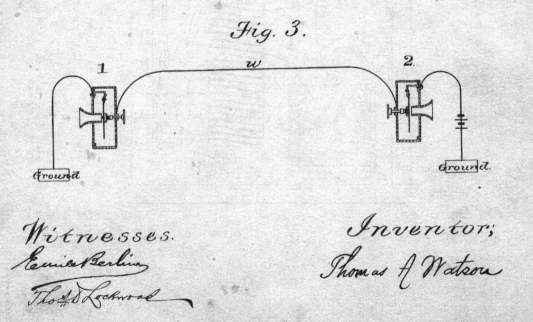

Fig. 3.

Witnesses. Inventor;
Emile Berliner Thomas A Watson
Thos. D. Lockwood

T. A. EDISON.
ELECTRIC METER.

No. 251,545. Patented Dec. 27, 1881.

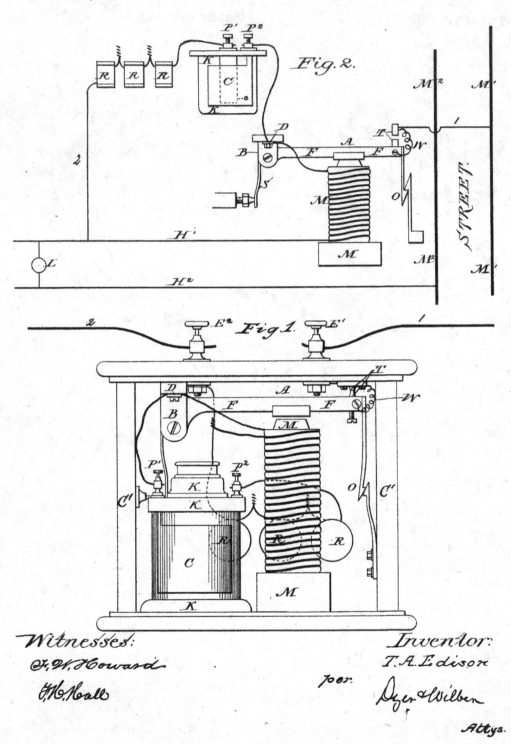

Fig. 2.

Fig. 1.

959,318. Patented May 24, 1910.

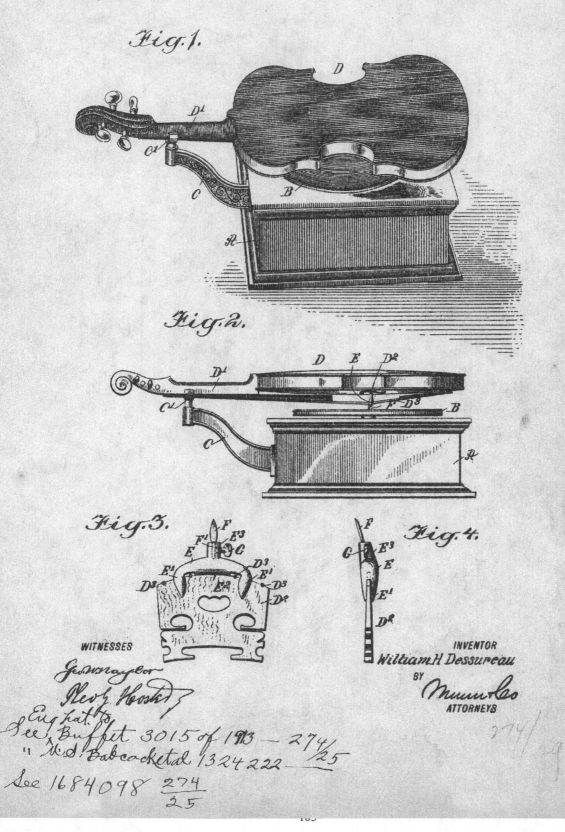

Fig.1.

Fig.2.

Fig.3. *Fig.4.*

WITNESSES

INVENTOR

William H. Dessureau

BY

Munn & Co

ATTORNEYS

S. SIEGEL.
TOY PIANO.
APPLICATION FILED MAY 10, 1915.

1,201,769.

Patented Oct. 17, 1916.
2 SHEETS—SHEET 1.

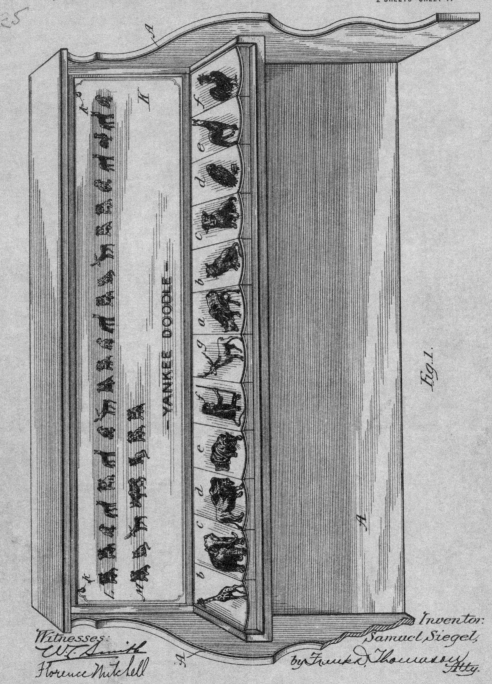

— YANKEE DOODLE —

Fig. 1.

H. Steinway, Jr.,

Piano Action.

Nº 32,386. Patented May 21, 1861.

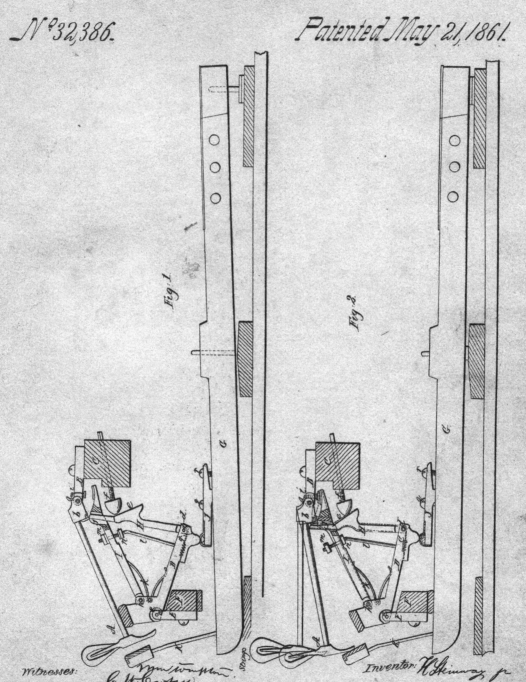

Fig. 1

Fig. 2

Witnesses: Inventor:
C. W. Cartar H. Steinway, Jr.

No. 638,385.

P. EVETTE.
SAXOPHONE.
(Application filed May 20, 1897.)

Patented Dec. 5, 1899.

(No Model.)

2 Sheets—Sheet 1.

Fig.1.

Fig.2.

Fig.3.

Fig.4.

Fig.5.

INVENTOR
Paul Evette
BY
Richards
ATTORNEYS

Fig. 1.

Fig. 4

Inventor:
Earl J. Gillespie.

By Brown, Jackson, Bottther & Dienner

Attys.

Fig.1

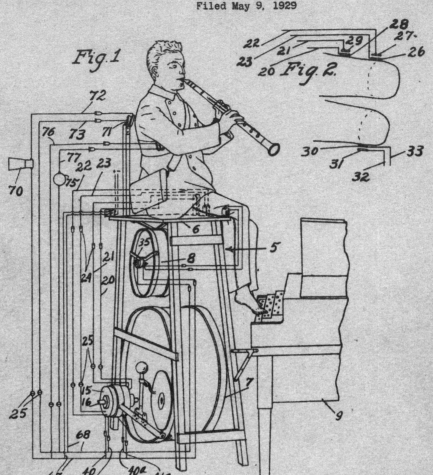

Fig. 2.

Fig. 3

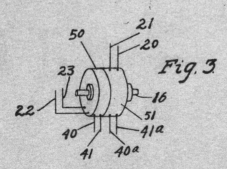

Fig. 4.

INVENTOR.

Paul T. F. Cenci

BY

Robt. W. Pearson

ATTORNEY.

W. L. BREATH.
PNEUMATIC GUN.

No. 599,549.

Patented Feb. 22, 1898.

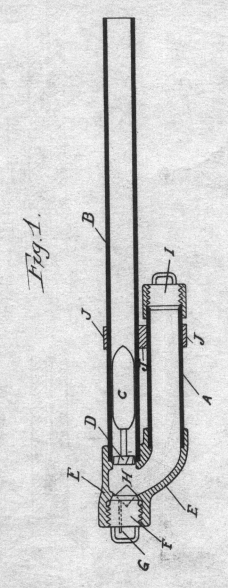

Fig. 1.

C. F. OUTLAW.
MAGAZINE GUN.
APPLICATION FILED OCT. 18, 1902.

NO MODEL.

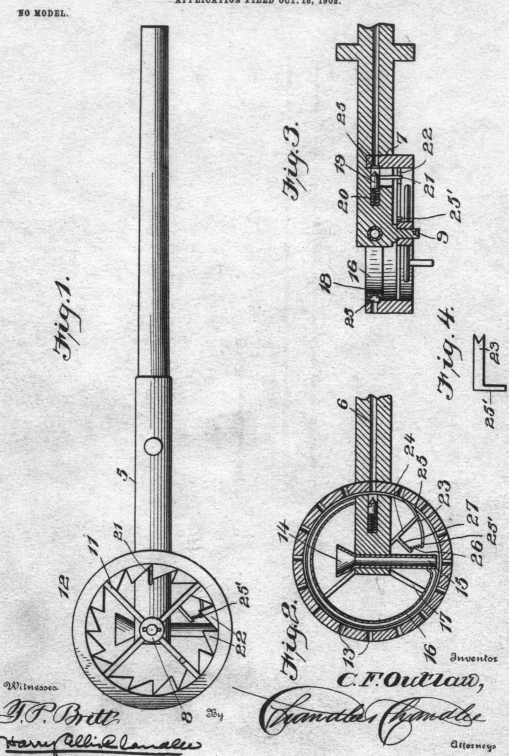

Fig.1.

Fig.3.

Fig.4.

Fig.2.

Witnesses

Y. F. Britt.

Harry Ellis Chandler

By

Inventor

C. F. Outlaw,

Chandler & Chandler

Attorneys

350

C. N. LEONARD.
STRAW STACKER.

No. 334,402. Patented Jan. 12, 1886.

Fig.1.

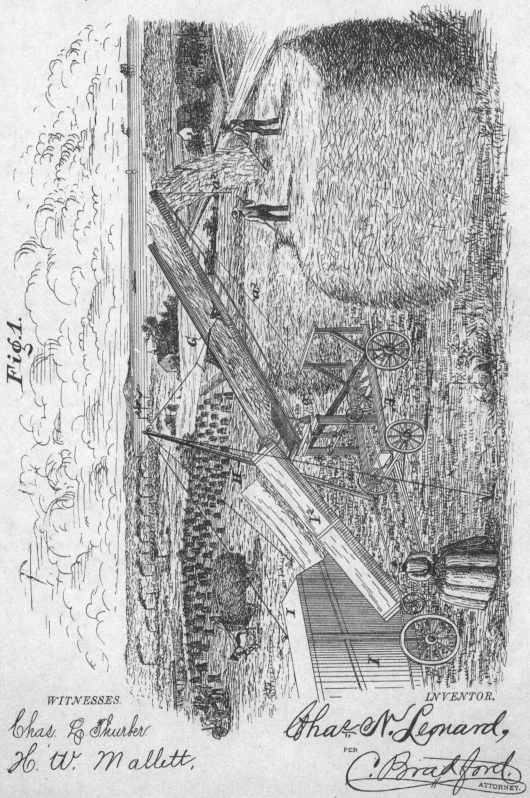

WITNESSES.
Chas. L. Thurber.
H. W. Mallett.

INVENTOR.
Chas. N. Leonard,
PER
C. Bradford.
ATTORNEY.

C. H. McCORMICK.

Plow.

7819 X

Patented Nov. 19, 1833.

T. Gregg.

Armor Clad.

Patented Mar. 19, 1814.

2081 X

Fig. 2.

Fig. 1.

J. S. Trott.
Screw Propeller.

No. 2,960 ½ x

Patented Jun. 2, 1818.

Fig. 1

Side view

X

2,031

oh

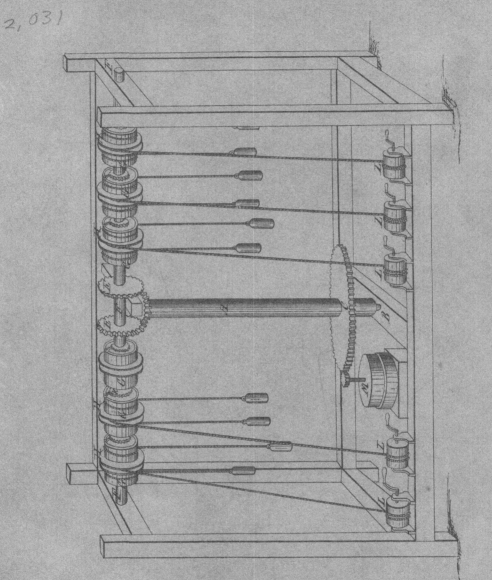

C. L. A. BRASSEUR.
COLOR PHOTOGRAPHY.
APPLICATION FILED FEB. 28, 1907.

1,163,207.

Patented Dec. 7, 1915.
2 SHEETS—SHEET 1.

Fig.1.

Fig.2.

Fig.3.

Fig.4.

Fig.5.

Fig.6.

Fig.7.

Fig.9.

Fig.8.

Witnesses

Inventor
Chas. L. A. Brasseur,
By his Attorney, R. W. Barkley.

W. Bedle.

Cradle.

N.º 55,227. *Patented June 5, 1866.*

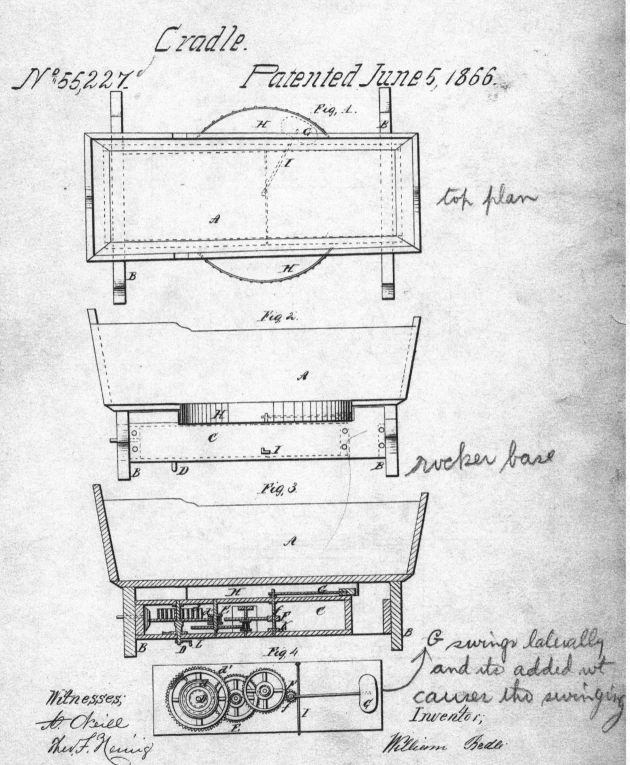

Fig. 1.

top plan

Fig. 2.

rocker base

Fig. 3.

Fig. 4.

G swings laterally
and its added wt
causes the swinging

Witnesses; Inventor;

A. O'Neill William Bedle

Thos. F. Haning

1,037,491.

Fig. 1.

Fig. 2.

WITNESSES:
M. H. Lindeman
Bert. C. Sandman.

INVENTOR
Charles F. Kettering

BY

Kerr, Page, Cooper & Hayward.
ATTORNEYS

No. 11,900.

R. DIESEL.
INTERNAL COMBUSTION ENGINE.
(Application filed July 3, 1900.)

Reissued Apr. 2, 1901.

2 Sheets—Sheet 1.

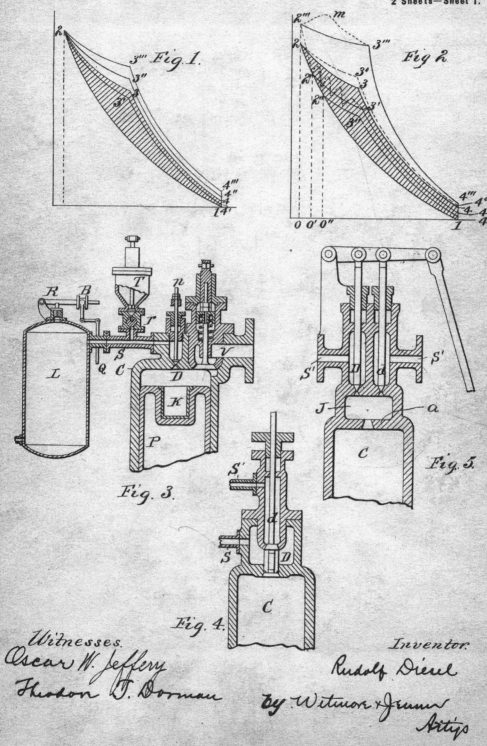

Fig. 1.

Fig. 2.

Fig. 3.

Fig. 4.

Fig. 5.

Witnesses.
Oscar W. Jeffery
Theodore T. Dorman

Inventor.
Rudolf Diesel
By Witmore & Jenner
Att'ys

L. RENAULT.

DRIVING AND SPEED CHANGING MECHANISM FOR MOTOR VEHICLES.

(Application filed July 22, 1899.)

(No Model.) 9 Sheets—Sheet 1.

Fig. 1

Witnesses:

C. E. Holske

J. B. Owens.

Inventor:

Louis Renault.

By

Attorneys.

H. FORD.
TRACTION ENGINE.
APPLICATION FILED AUG. 19, 1910. RENEWED NOV. 11, 1914.

1,153,052.

Patented Sept. 7, 1915.
3 SHEETS—SHEET 1.

Fig.1

Inventor
HENRY FORD

By

Attorneys

T. A. EDISON.
ELECTRIC LOCOMOTIVE.

No. 493,425.

Patented Mar. 14, 1893.

Fig. 1.

Varies speed by
magnetic clutch.
of friction type
—slip all about
4 r.v. for.

Witnesses
Norris H. Clark.
H. F. Oberly.

Inventor
T. A. Edison
By his Attorneys
Dyer & Seely.

315/66

No. 817,146. PATENTED APR. 3, 1906.

J. McCULLOUGH.
SWITCHING DEVICE FOR ELECTRIC LAMPS.
APPLICATION FILED JUNE 23, 1903.

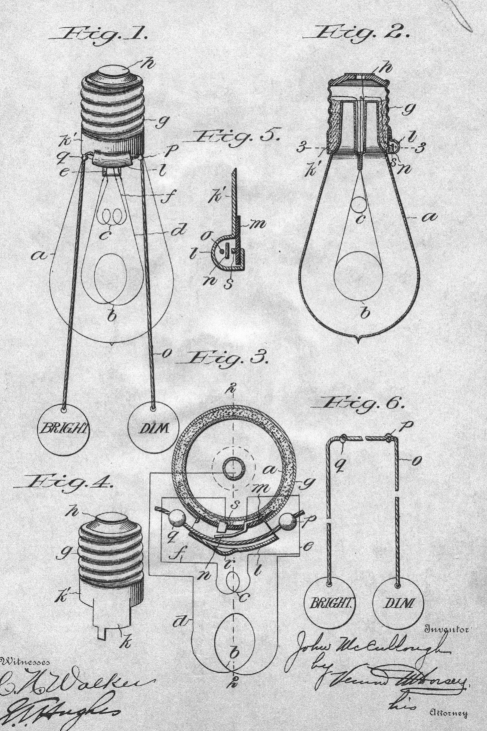

Fig.1. Fig.2.

Fig.5.

Fig.3.

Fig.4. Fig.6.

BRIGHT DIM

BRIGHT. DIM

X
TX2005

Witnesses Inventor
C. H. Walker John McCullough
G. W. Hughes by Vernon Attorney
 his Attorney

F. A. GRAHAM.
LIFE BOAT,
APPLICATION FILED SEPT. 11, 1917.

1,278,141.

Patented Sept. 10, 1918.
2 SHEETS—SHEET 1.

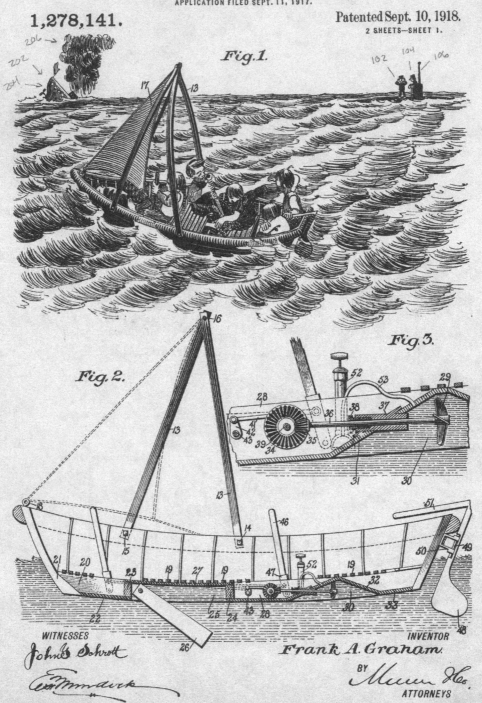

Fig.1.

Fig.2.

Fig.3.

WITNESSES

INVENTOR

Frank A. Graham.

BY

ATTORNEYS

W. G. A. BONWILL.
DENTAL ENGINE.

No. 372,397. Patented Nov. 1, 1887.

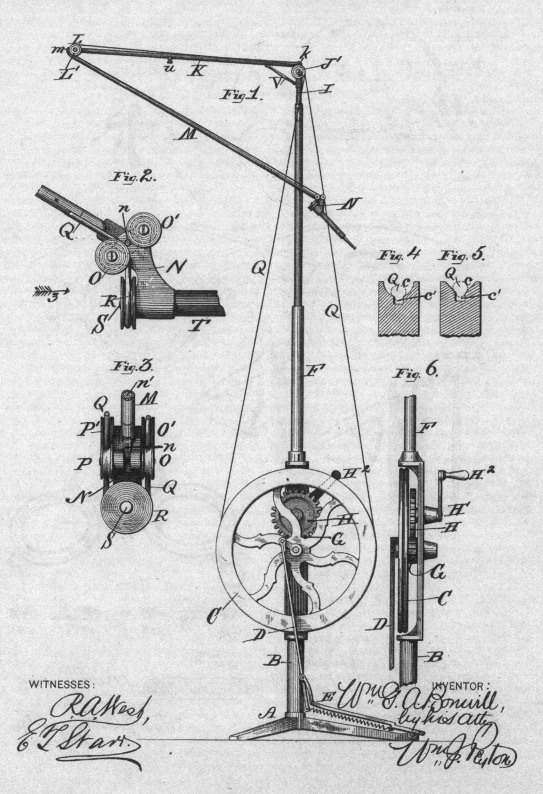

Fig. 1.

Fig. 2.

Fig. 3.

Fig. 4. Fig. 5.

Fig. 6.

WITNESSES:
R. A. West,
E. T. Start.

INVENTOR:
Wm. G. A. Bonwill,
by his atty
Wm. P. Peyton

No. 669,949.

Patented Mar. 12, 1901.

J. B. UNDERWOOD.
FACIALLY SUPPORTED LIGHTING DEVICE.
(Application filed July 7, 1899.)

(No Model.)

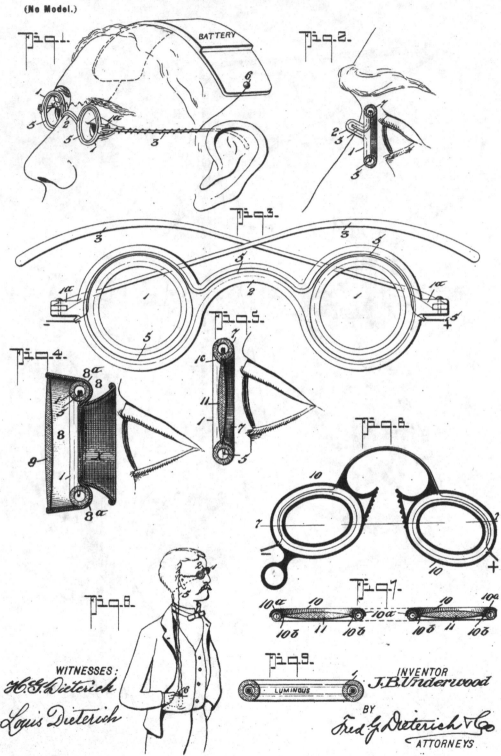

BATTERY

LUMINOUS

INVENTOR
J. B. Underwood
BY
Fred G. Dieterich & Co
ATTORNEYS

M. NIÉLL.
PHOTOGRAPHIC CAMERA.
APPLICATION FILED OCT. 14, 1903.

NO MODEL.

WITNESSES:
H. Walker
C. R. Ferguson

INVENTOR
Magnus Niéll
BY
Munn
ATTORNEYS

1,262,394.

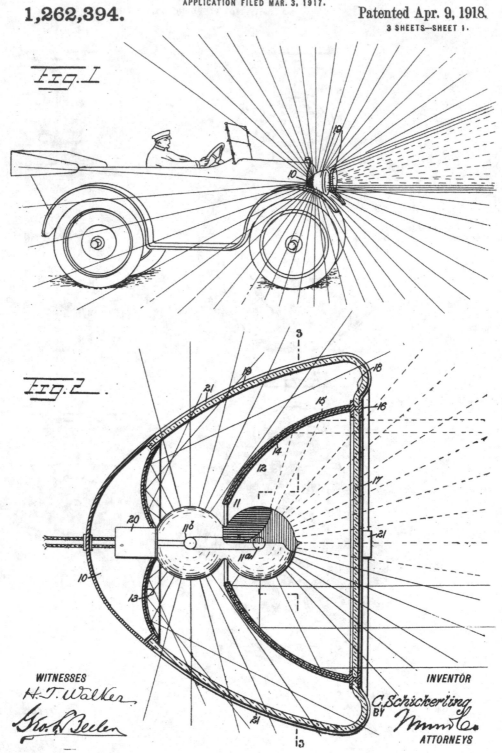

Fig.1

Fig.2

WITNESSES
H. J. Walker
Geo. L. Beeler

INVENTOR
C. Schickerling
BY
Mmmm Co.
ATTORNEYS

A. MAUL.
ROCKET APPARATUS FOR TAKING PHOTOGRAPHS.
APPLICATION FILED JUNE 20, 1903.

NO MODEL. 2 SHEETS—SHEET 1.

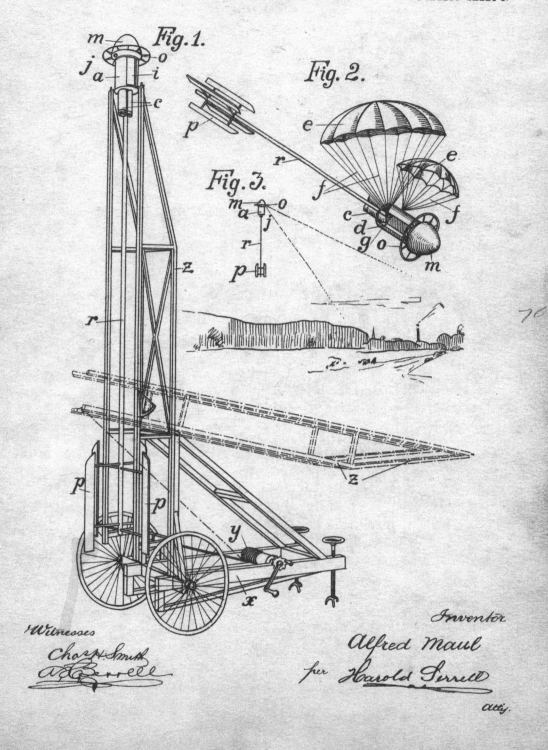

Fig.1.

Fig.2.

Fig.3.

Witnesses

Chas H. Smith

A. H. Berrell

Inventor

Alfred Maul

per Harold Sorrell

Attiy.

1,226,308.

Patented May 15, 1917.
3 SHEETS—SHEET 1.

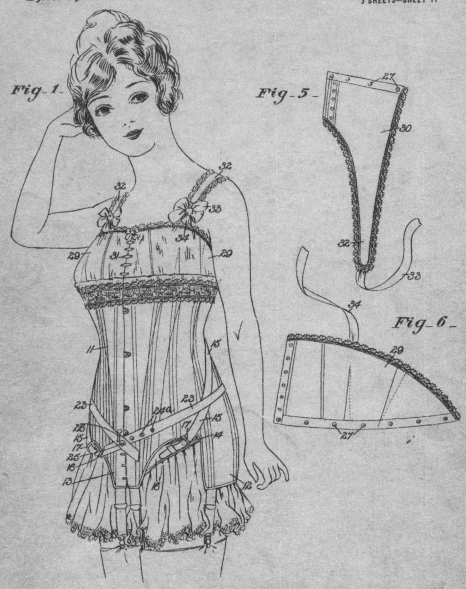

Fig_1_

Fig_5_

Fig_6_

WITNESSES
Frank C. Palmer.

INVENTOR
L.A.Cirillo
BY
ATTORNEYS

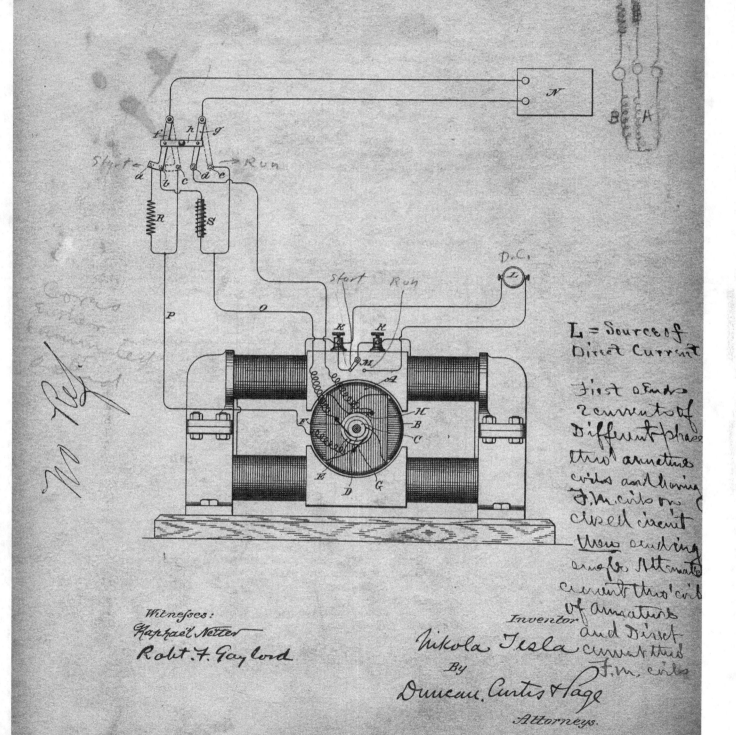

L = Source of
Direct Current

First of Ends
2 currents of
Different phase
thro' armature
coils and having
F.M. coils on
closed circuit
then sending
one of Alternate
current thro' coils
of armature
and Direct
current thro'
F.M. coils

Witnesses:
Raphaël Netter
Robt. F. Gaylord

Inventor
Nikola Tesla
By
Duncan, Curtis & Page
Attorneys.

L. D. LANGWORTHY.
PROCESS OF AND APPARATUS FOR COPYING PICTURES.

No. 561,797. Patented June 9, 1896.

Fig. 1.

may draw picture on either surface

WITNESSES:
Charles W. Morris,
Jessie E. Murray.

INVENTOR
Lynn D. Langworthy.
BY
Smith & Brinson
ATTORNEYS.

Picture produced from drawing a by lantern projection. Spon, Workship Rec I p488.

T. W. H. MOSLEY.
Construction of Iron Buildings.

No. 106,854.

Patented Aug. 30, 1870.

Fig. 1.

Fig. 2.

Fig. 3.

Fig. 4.

T 30
x 1347

Witnesses:
H. B. Deming
Wm. H. Brereton Jr.

Inventor:
T. W. H. Mosley
By Knight Bros.
Attorneys

S. S. WHEELER.
ELECTRIC ELEVATOR.

No. 273,208.

Patented Feb. 27, 1883.

Fig. 1.

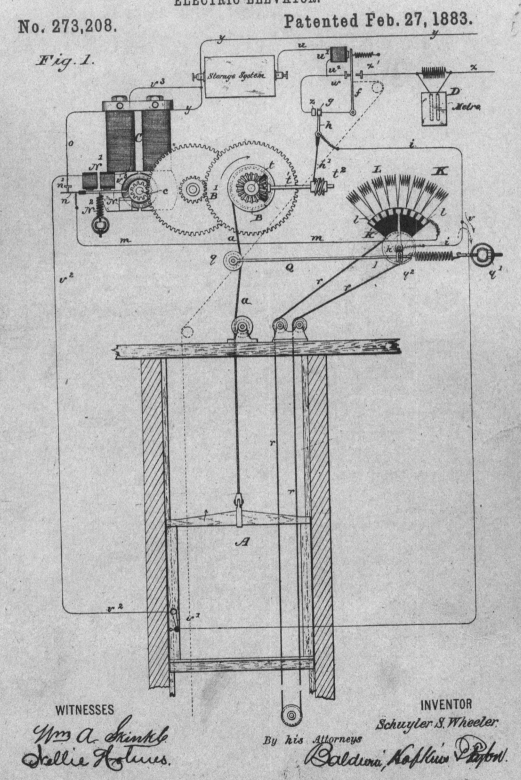

WITNESSES

Wm A. Skinkle

Nellie Holmes.

INVENTOR

Schuyler S. Wheeler.

By his Attorneys

Baldwin, Hopkins & Payton.

C. Whipple.

Rope Mach.

No 7,130. Patented Feb. 26, 1850.

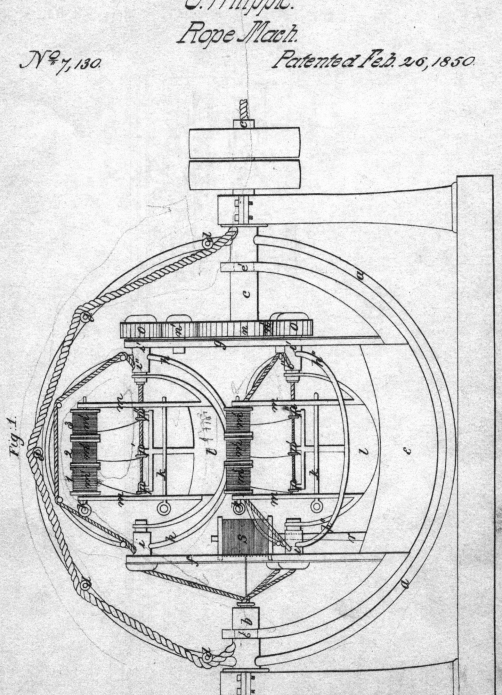

Fig. 1.

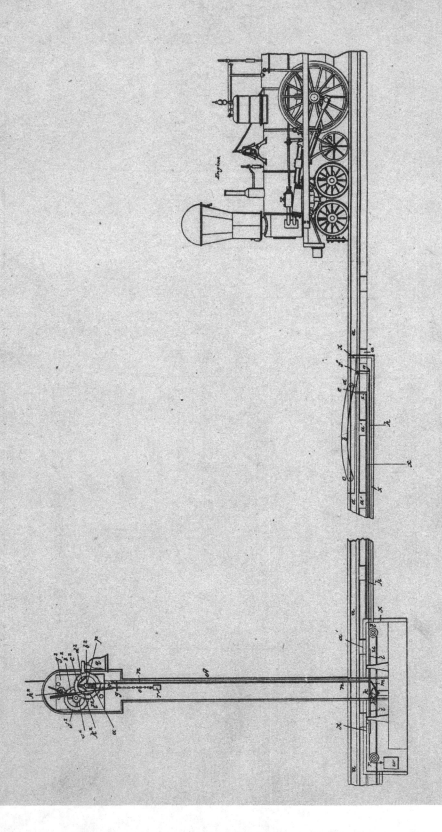

Fig.1.

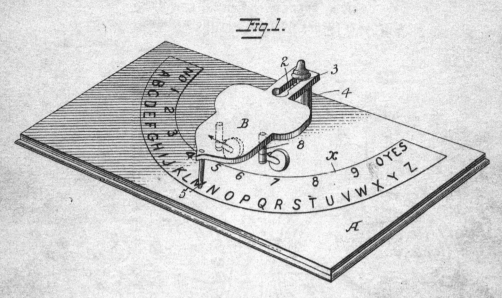

Fig.2.

Fig.3.

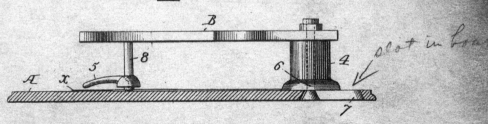

slot in board

9079

No. 644,166.

Patented Feb. 27, 1900.

W. A. FRERET, Jr. & H. S. LEWIS.

CRYPTOGRAPHIC TYPE WRITING MACHINE.

(Application filed Aug. 11, 1899.)

(No Model.)

2 Sheets—Sheet 1.

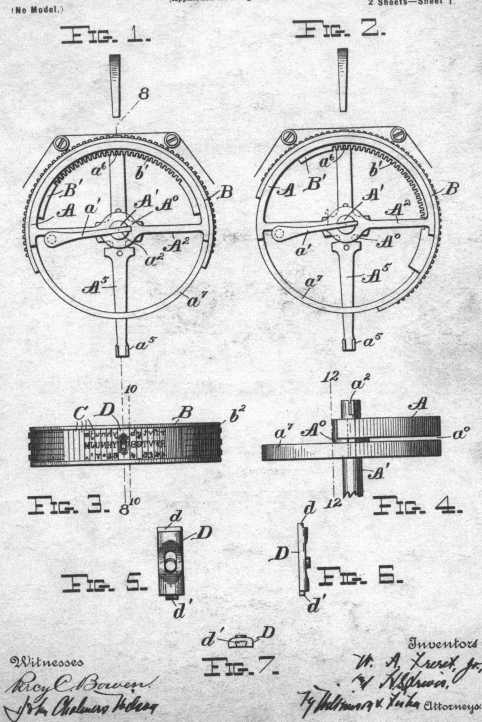

FIG. 1. FIG. 2.

FIG. 3. FIG. 4.

FIG. 5. FIG. 6.

FIG. 7.

Witnesses

Percy C. Bowen.

John Chalmers Holms

Inventors

W. A. Freret, Jr.,

H. S. Lewis,

Fy Wilkins & Fisher Attorneys

[15 - 209]

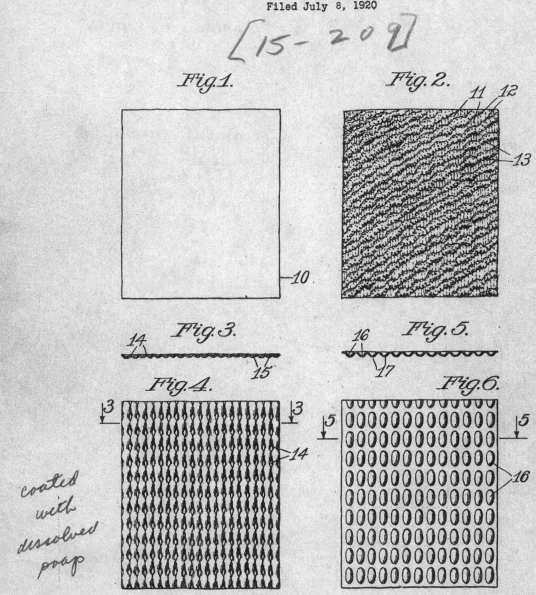

Fig.1.

Fig.2.

Fig.3.

Fig.5.

Fig.4.

Fig.6.

coated
with
dissolved
soap

Inventor:
William A. Lorenz
by B.C. Stickney
Atty.

H. G. FISKE.
Dental Attachment for Telephones.

No. 228,254. Patented June 1, 1880.

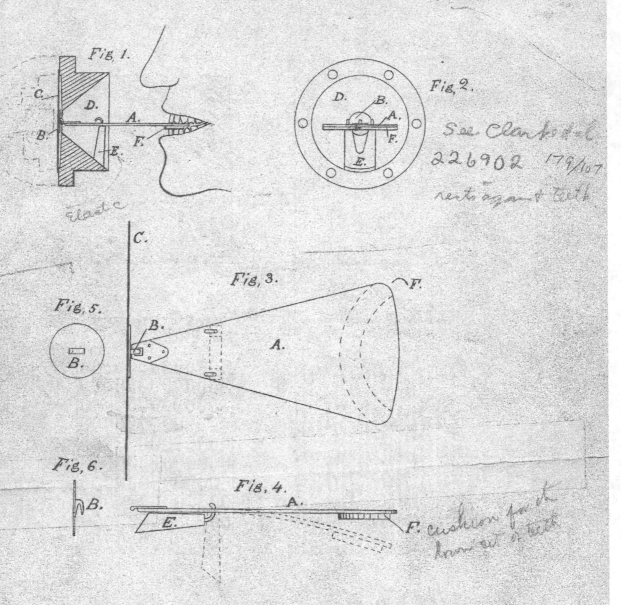

Fig. 1.

Fig. 2.

See Clark &c &c
226902 179/107
rests against teeth

Fig. 5.

Fig. 3.

Fig. 6.

Fig. 4.

F. cushion for it
base of teeth

Witnesses;

Arthur H. Fay.

George M. Fisk.

Inventor;

Henry G. Fiske.

No. 672,193.

D. McK. McKINLAY.

METHOD OF FINDING SURFACE FORMS FOR CYCLE SADDLES.

(Application filed Dec. 30, 1897.)

Patented Apr. 16, 1901.

(No Model.)

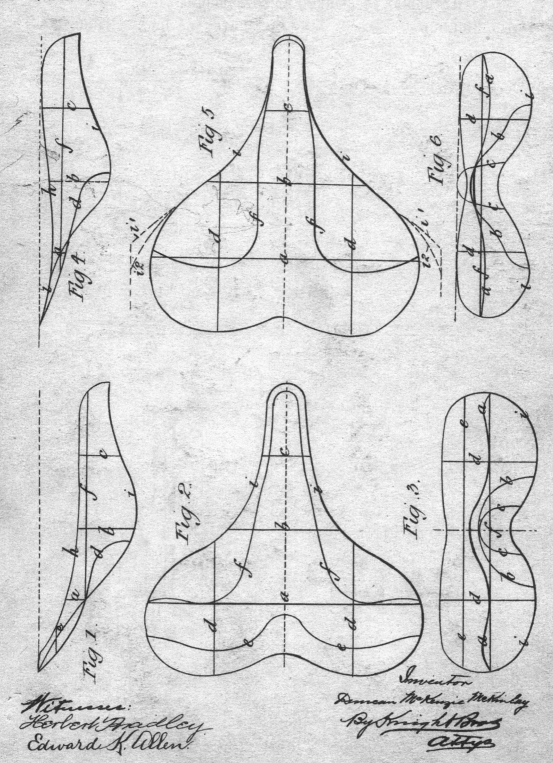

Inventor
Duncan McKenzie McKinlay
By Knight Bros
Attys

T. A. EDISON.
METHOD OF RECORDING AND REPRODUCING SOUNDS.

No. 393,966. Patented Dec. 4, 1888.

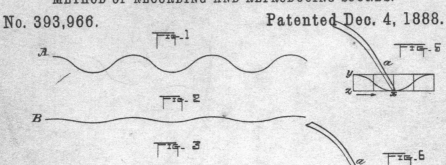

Fig-1

Fig-5

Fig-2

Fig-6

Fig-3

Fig-4

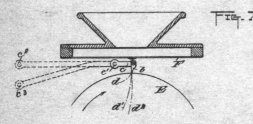

Fig-7

Fig-8

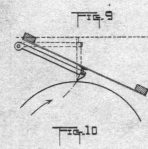

Fig-9

Fig-11

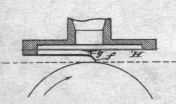

Fig-10

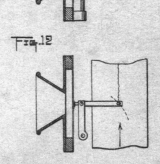

Fig-12

WITNESSES:
E C Rowland
William Pzer.

INVENTOR.
Thomas A. Edison.
BY
Dyer & Seely
ATTORNEY

S. COLT.
Revolver.

No. 7,629.

Patented Sept. 10, 1850.

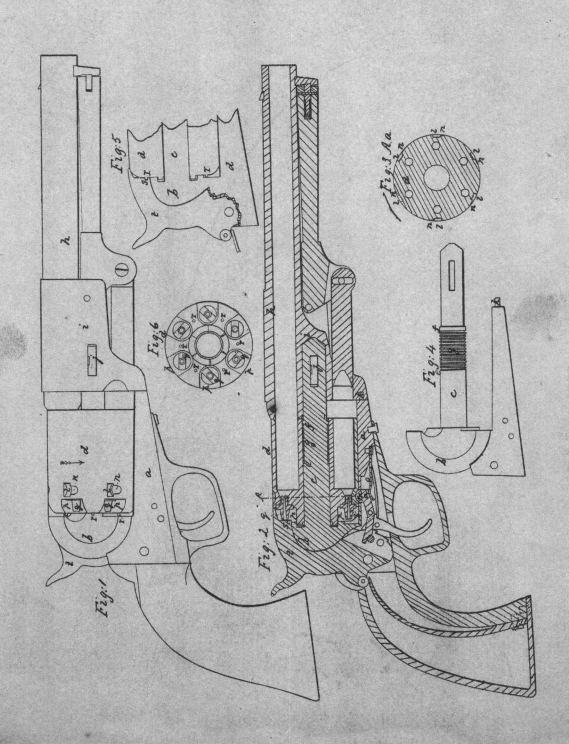

F. LESTER.
PORT REGULATING VALVE.

No. 545,081. Patented Aug. 27, 1895.

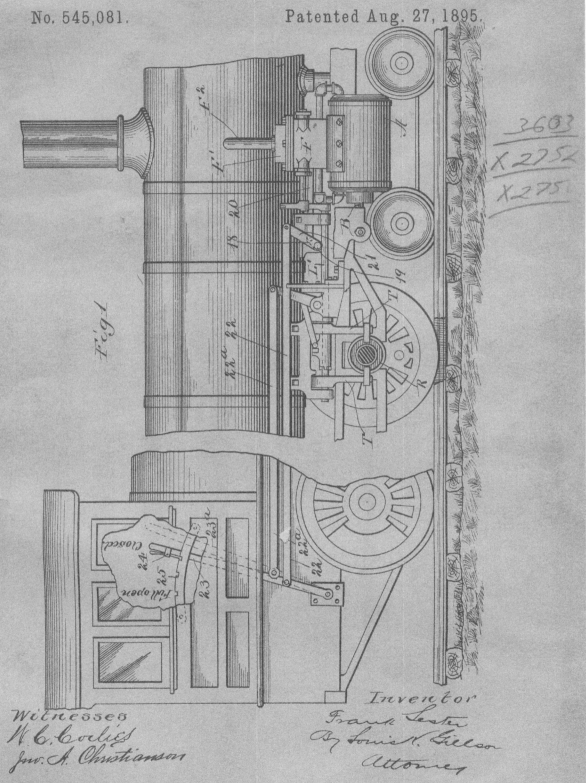

Witnesses

W. C. Coolies

Jno. A. Christianson

Inventor

Frank Lester

By Louis K. Gibson

Attorney

F. E. Sickle.
Steering.

Nº 9,713

Patented May. 10, 1853.

1005

Apex on back

L. H. WATTLES.
SYSTEM OF GENERATING AND USING HYDROGEN GAS AND ELECTRICITY.

No. 583,104.　　　　　　　　　　　　　Patented May 25, 1897.

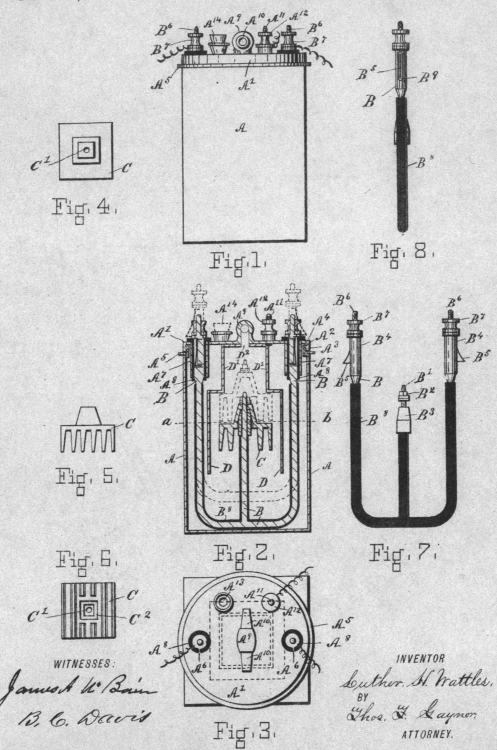

Fig. 1.　　Fig. 4.　　Fig. 8.

Fig. 5.　　Fig. 2.　　Fig. 7.

Fig. 6.　　Fig. 3.

WITNESSES:
James A. McBain
B. C. Davis

INVENTOR
Luther H. Wattles.
BY
Thos. F. Laynor.
ATTORNEY.

A. MILLS.
MECHANISM FOR UTILIZING TIDE POWER.

No. 424,566.

Patented Apr. 1, 1890.

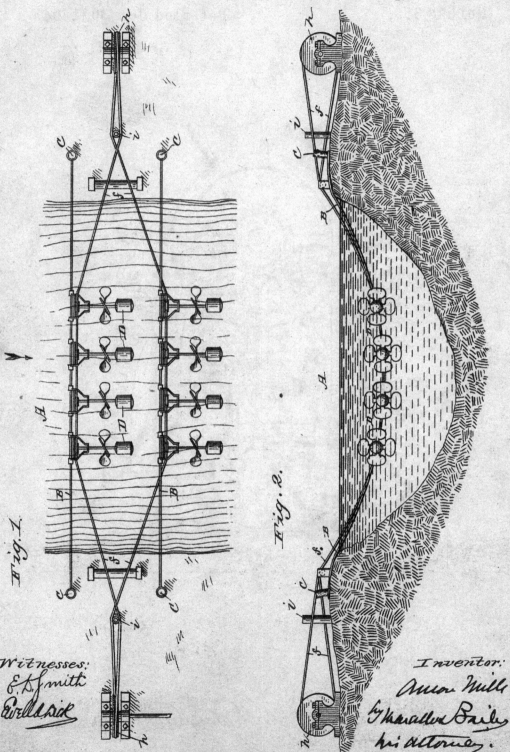

Fig. 1.

Fig. 2.

Witnesses:
E. A. Smith
Everddick

Inventor:
Amos Mills
by Maratlos Bailey
his attorney.

(No Model.)

3 Sheets—Sheet 1.

M. A. BECK.
STEERING ENGINE.

No. 528,356.

Patented Oct. 30, 1894.

Fig.1.

1005
X 1168
X 1139
X 1014
X 3143
X 4053
X 4039

Witnesses:
E. C. Asmus
Chas. R. Gov.

Inventor:
Matthias A. Beck,
By Dick C. Hinten Smith, Bottum & Abs
Attorneys.

I. M. Heath.

Making Cast Steel.

Nº 4,822.

Patented Oct. 24, 1846.

Fig. 1

Fig. 2

I. C. BRYANT.

Blast Furnace.

No. 1,057.

Patented Dec. 31, 1838.

Fig. 7.
Fig. 2.
Fig. 1.
Fig. 4.
Fig. 5.
Fig. 3.
Fig. 6.

G. Sibbald.

Magic Lantern.

N.º 42,412. Patented Apr. 19, 1864.

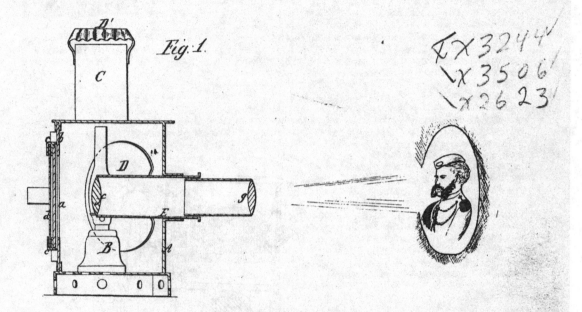

Fig. 1.

Fig. 2.

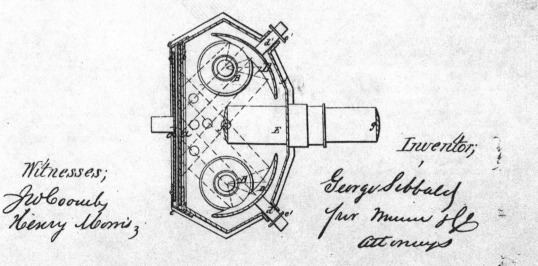

Witnesses;
J. W. Coomby
Henry Morris;

Inventor;
George Sibbald
Per Munn & Co.
Attorneys

J. A. Bailey,

Fishing Reel.

N̊ 15,466.

Patented Aug. 5, 1856.

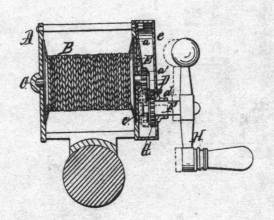

No. 618,634.

Patented Jan. 31, 1899.

F. N. YOUNG & F. E. THOMPSON.

VEHICLE BODY.

(Application filed Aug. 27, 1898.)

(No Model.)

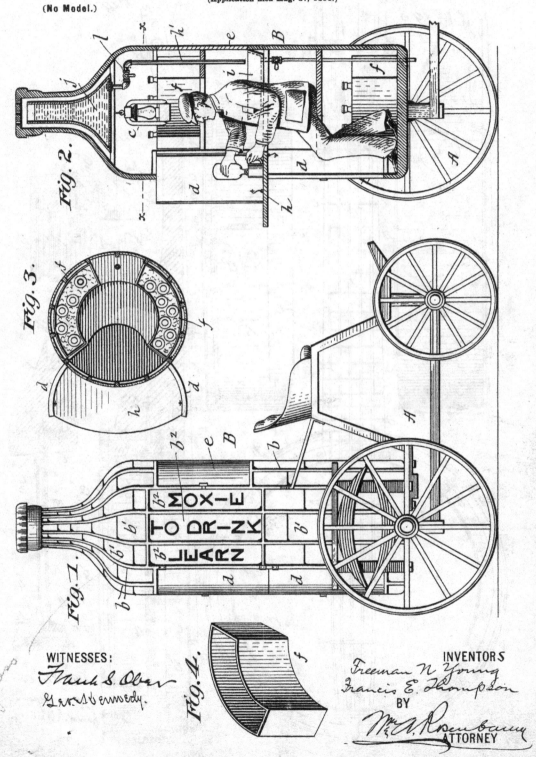

Fig. 2.

Fig. 3.

Fig. 1.

Fig. 4.

WITNESSES:

Frank S. Ober

Geo A Kennedy.

INVENTORS

Freeman N Young

Francis E. Thompson

BY

Wm A Rosenbaum

ATTORNEY

B. BRADBURY.
BANJO.

No. 262,564. Patented Aug. 15, 1882.

Fig. 1.
Fig. 2.
Fig. 3.
Fig. 4.
Fig. 5.
Fig. 6.

Witnesses
Rob't W. Matthews
Thomas E. Crossman

Inventor
Benjamin Bradbury,
per
James A. Whitney,
atty.

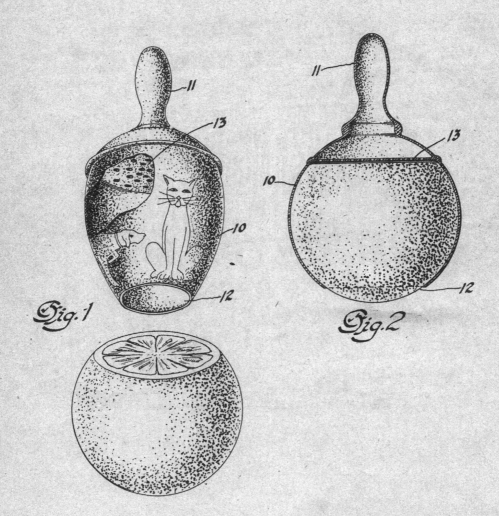

Fig. 1

Fig. 2

Inventor

Lena Brooke McNamara

By

Attorney

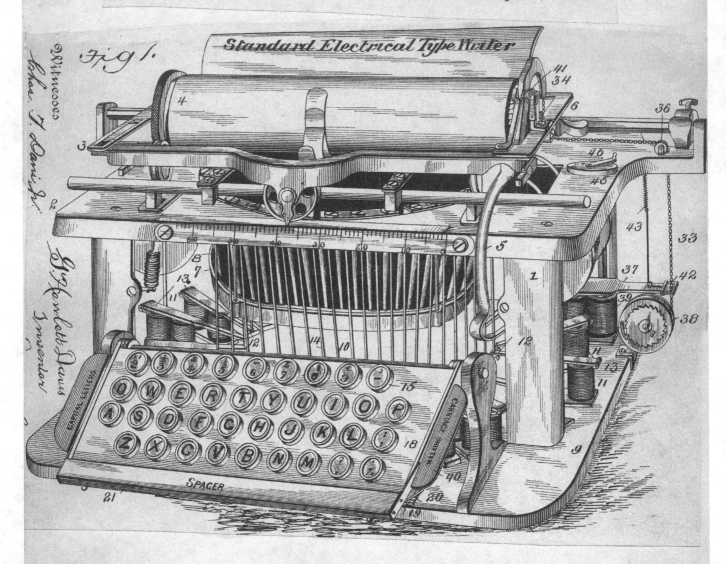

H. HOUDINI.

DIVER'S SUIT.

APPLICATION FILED JUNE 30, 1917.

1,370,316. Patented Mar. 1, 1921.

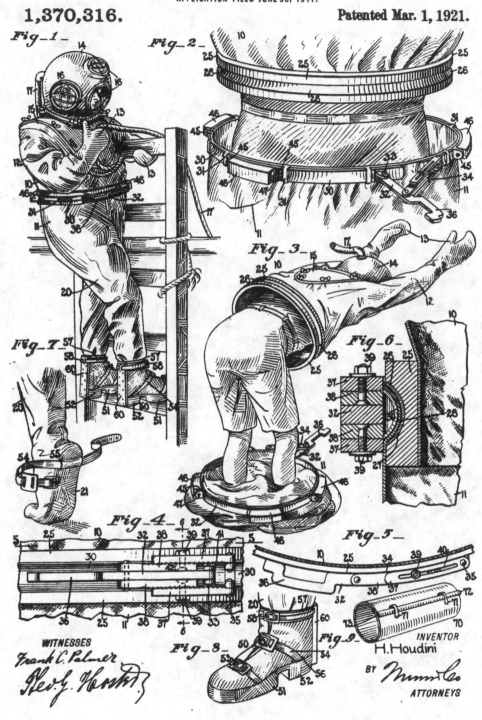

Fig_1_

Fig_2_

Fig_3_

Fig_6_

Fig_7_

Fig_4_

Fig_5_

Fig_8_

Fig_9_

M. P. JACOB.
BRASSIÈRE.
APPLICATION FILED FEB. 12, 1914.

1,115,674.

Patented Nov. 3, 1914.
2 SHEETS—SHEET 1.

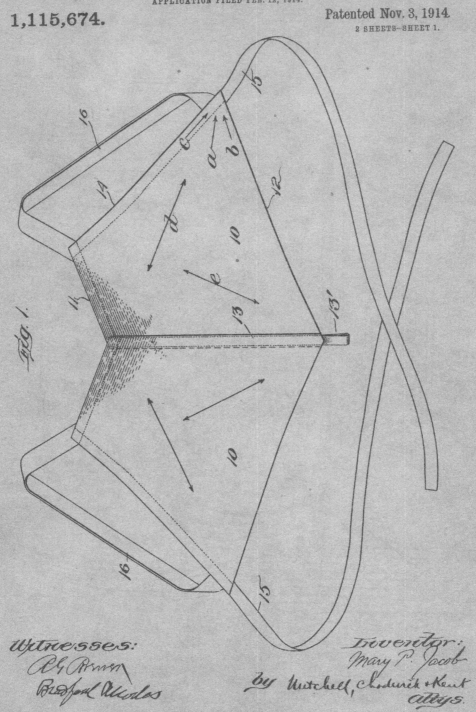

Fig. 1.

Witnesses:
R. G. Rever
Bradford Allerdos

Inventor:
Mary P. Jacob
by Mitchell, Chadwick & Kent
Attys.

MARK TWAIN
S. L. CLEMENS.
GAME APPARATUS.

No. 324,535. Patented Aug. 18, 1885.

A *Fig. 1.*

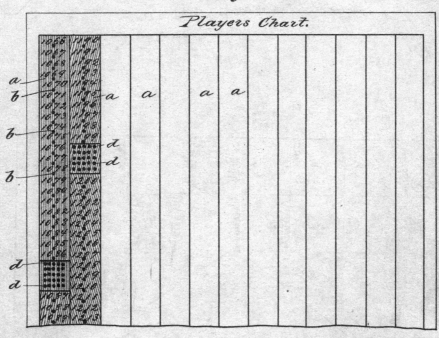

Players Chart.

Fig. 2.

B

Hastings, Conquest, Overthrow of Saxons.

Umpir...

WITNESSES: INVENTOR:

Theo. G. Hoster. S. L. Clemens

C. Sedgwick BY Munn & Co.

 ATTORNEYS.

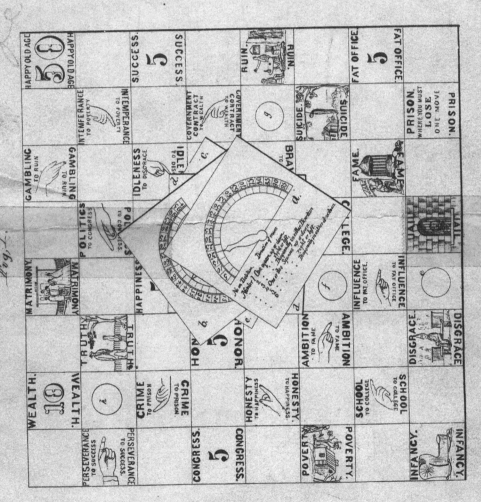

Fig. 1.

Fig. 2.

371

927,244.

Patented July 6, 1909.

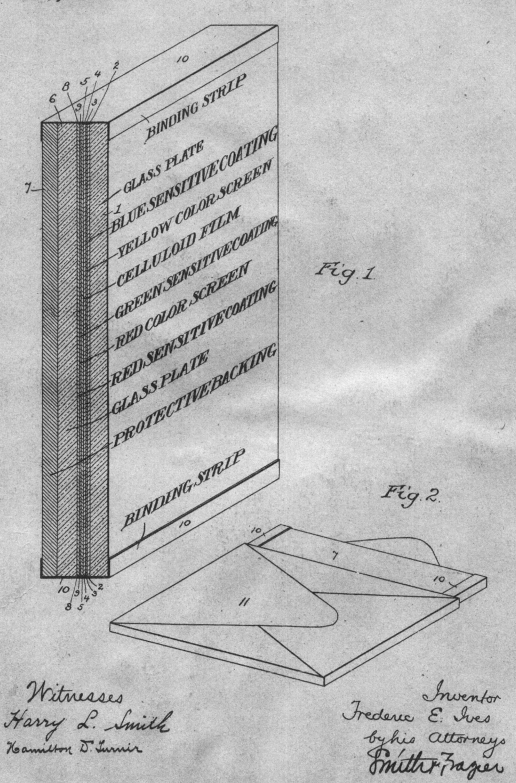

BINDING STRIP

GLASS PLATE

BLUE SENSITIVE COATING

YELLOW COLOR SCREEN

CELLULOID FILM

GREEN SENSITIVE COATING

RED COLOR SCREEN

RED SENSITIVE COATING

GLASS PLATE

PROTECTIVE BACKING

BINDING STRIP

Fig. 1.

Fig. 2.

Witnesses
Harry L. Smith
Hamilton D. Turner

Inventor
Frederic E. Ives
by his Attorneys
Smith & Bayer

H. G. FISKE.
Dental Attachment for Telephones.

No. 228,254. Patented June 1, 1880.

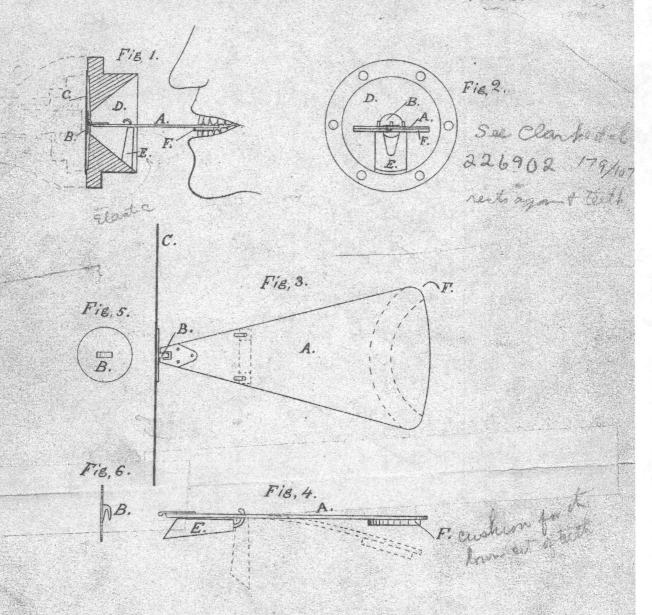

Witnesses;

Arthur H. Fay.

George M. Fisk.

Inventor;

Henry G. Fiske.

United States Patent Office.

ADOLPH RIMANOCZY, OF CINCINNATI, OHIO, ASSIGNOR TO THE STROBRIDGE LITHOGRAPHING COMPANY, OF SAME PLACE.

ART OF RENDERING PAPER INIMITABLE.

SPECIFICATION forming part of Letters Patent No. 411,059, dated September 17, 1889.

Application filed April 13, 1889. Serial No. 307,166. (No specimens.)

To all whom it may concern:

Be it known that I, ADOLPH RIMANOCZY, a subject of the Queen of Great Britain, residing in Cincinnati, county of Hamilton, and State
5 of Ohio, have invented a new and useful Improvement in the Art of Rendering Paper Inimitable, of which the following is a specification.

There is a large and continually-increasing
10 demand for paper which cannot be duplicated by unauthorized parties, for use in printing certificates of stock, bonds, drafts, notes, commercial paper, &c.

The object of my invention is to provide
15 paper of peculiar designs which cannot be successfully duplicated by unauthorized parties. This I accomplish as follows: I take a lithographic plate of stone or other material, apply ink to the face of the plate, place an-
20 other plate, which may also be a lithographic plate, face to face with the first-named plate, rub the faces of the two plates together for a time, and then take them apart. The ink will be so distributed by the rubbing action
25 that a variegated design will be produced upon the plate. If this design is not pleas-

ing, the plates are again placed together and the rubbing continued until a satisfactory design is produced. The ink is then allowed to dry and the lithographic plate subjected to 30 the usual treatment for lithographic purposes and the design transferred to the paper in the usual manner of printing from lithographic plates. It will be found that this method produces designs of such infinite variety of 35 configuration and shade that reproduction, except from the original plate, is practically impossible.

The impression may be made in any desired color. 40

I claim as my invention—

The herein-described process of rendering paper inimitable, consisting in rubbing ink upon the face of a lithographic plate by means of another plate and transferring to paper 45 by lithographic process the design so produced.

ADOLPH RIMANOCZY

Witnesses:
JAMES N. RAMSEY,
G. V. FRY.

Patent Art

The US Patent drawings shown in this book are, in most cases, more than a century old.

Drawn with ruling pens and India ink, the illustrations were often made from scale models. Lithography, a process using etched copper plates, was used to obtain nearly perfect copies. Paper technology was just transitioning between cotton and wood pulp, and page sizes had not been standardized. But the quality was exceptional, as many decades of handling have proven.

When the Patent Office digitized the collection, low resolution scans failed to capture the fine details of the originals. And, the copies were "clean" – missing were decades of examiner-added notes handwritten in the margins of many patents.

The digital images of the lithographs in this book were produced at 300dpi, and still do not do justice to the original artwork.

Epilog

In many cases, a patent is the only remaining evidence that an invention ever existed. The written record provides something the actual invention usually lacks: an understanding of how it works, why it was needed, how it was made, and what problem it was meant to solve. Even a brief review of the drawings in this book shows a clear link between the needs and solutions of today and those of a century ago. As the inventor of a new hybrid vehicle, a new light source, or a medical device, you may find it at first humbling and then inspiring to realize your idea has a long pedigree.

CREDITS:

Writing a book and inventing have a lot in common: both inevitably benefit from the contributions and assistance of others. For generously giving their time, skills and ideas, the authors wish to express their sincere gratitude to the following:

Jade Goetz and **Wendy Goetz** for their creativity and energy
Susan Bold, for graphic processing of the images
Kristina Phillips for cover design
Luke Rabin, for graphic processing of the images
The staff at Apple Computer – for generously assisting with layout
issues. What a great company.
Elln Hagney & Dan Yaeger of the Charles River Museum of Industry & Innovation.

For generously lending graphics of the groundbot on the back cover:

Per Samuelsson
John MacNeill
Rotundus AB of Sweden

Don't forget: Visit our website **www.drawingonbrilliance.net** *and* **www.drawingonbrilliance.com** *for more information!*

About Jackie Bassett

Jackie Bassett is founder and CEO of BT Industrials Inc., a strategic management and technology consultancy where she helps CEOs of global 500 companies with their innovation strategies. Her expertise is in closing the "Business-to-Technology strategy" gap by identifying ways to turn problems into profits.

She was one of the first 100 employees at Netscreen Technologies; which started in 1997, successfully IPO'd in 2001, then was acquired by Juniper Networks in 2004 for $4Billion.

As subject matter expert she has published many articles in Security Technology & Design, IT Audit Magazine, Director's Monthly, Tornado-Insider and Technology Planning Magazine. Bassett's first book 'So You Built It & They Didn't Come. Now What?" received outstanding reviews from MIT, Venture Capitalists and several high profile entrepreneurs.

She co-authored her second book with Dan Rothman of DISA. *"A Seat At The Table For CEOs and CSOs: Driving Profits, Corporate Performance and Business Agility"* which Network World recommended as required reading for every CISO involved with corporate strategy.

Her background is in investment banking having worked for nearly a decade at State Street International as Assistant Treasurer for Capital Markets - Eurodollar Trading.

Bassett works extensively with CEOs and CIOs on strategic planning issues specializing in innovation strategies. She holds an MBA from Babson College and a private pilot's license.

BT Industrials specializes in:

- New customer acquisition and new product development
- Capturing and growing customer knowledge, conversations and insights
- Digital Marketing - Identifying and delivering what customers want
- Closing the Business to Technology strategy gap for CEOs & CFOs
- Root cause analysis to turn problems into profits

Jackie can be reach at: jackieb@btind,com or go to: www.btind.com

About Randy Rabin

Randy Rabin is founder of PatentArts, an invention and patent research service for inventors, companies, and patent law firms. Its small group of researchers has worked in almost every area of technology including semiconductors, communications, optics, medical devices, surgical techniques, turbines, fuel cells, and solar power generation systems.

Prior to PatentArts, he founded MicroTronics, Inc. to custom build computers, including designing a computer kit and a training program for the Peace Corps. The kits became the basis for small industries in a number of developing countries around the world.

He lectures to MBA classes on the subject of invention, patents and innovation, and assists companies to develop their inventions to be competitive and patentable. A lifelong inventor, he is developing three inventions in the medical device field about to enter the patent application stage.

In 2001 his efforts to stop the US Patent Office from destroying the 200 year old patent library were featured in the New York Times, Forbes, and more than a dozen other publications in three countries. The documents featured in this book were saved from that destruction over a four-year span.

Randy can be reached at: rdr@patentarts.com